Cedar Key
FLORIDA
A History

KEVIN M. McCARTHY

Charleston London

History
PRESS

Published by The History Press
Charleston, SC 29403
www.historypress.net

Cover images:
top: View across the marina. *Courtesy of Kevin M. McCarthy.*
bottom: View on the marsh. *Courtesy of Kevin M. McCarthy.*

First published 2007

Manufactured in the United Kingdom

ISBN 978.1.59629.310.6

Library of Congress Cataloging-in-Publication Data

McCarthy, Kevin (Kevin M.)
Cedar Key, Florida : a history / Kevin M. McCarthy.
p. cm.
ISBN 978-1-59629-310-6 (alk. paper)
1. Cedar Key (Fla.)--History. I. Title.
F319.C43M38 2007
975.9'77--dc22

2007019692

Contents

Preface

The group of islands in Levy County—on the west coast of Florida about ninety miles north of Tampa and fifty-five miles west of Gainesville—consists of five large islands and many smaller ones. The four westernmost islands—Bird, North, Seahorse and Snake Keys—make up the Cedar Keys National Wildlife Refuge. The town of Cedar Key is on Way Key, which is separated from the mainland by a salt marsh and is on an island three miles from the mainland and about twenty miles from Otter Creek to the east.

This is the story of the islands in general and Cedar Key in particular—how they played a role in the nineteenth-century history of Florida, weathered some strong hurricanes and political machinations and slowly evolved into one of the state's prettiest enclaves. In the first decade of the twenty-first century they find themselves struggling to maintain their rustic charm, but at the same time adapting to modern pressures of development in a way that does not destroy their unique personality. Unlike many, many other parts of Florida—parts that have given in to the developer, destroyed historic structures and paved over much of what was significant—Cedar Key has resisted such temptations, but at the same time has had to reinvent itself several times: from a reliance on the fragile cedar trees to over-fishing in the nearby Gulf of Mexico by others to an accommodation with tourism.

First and foremost, I wish to thank Lindon Lindsey, whose collection of old photographs and newspaper clippings has made the writing of this book a real joy. He is one of the nicest people I have ever worked with, and I dedicate this book to him and all the other people of Cedar Key who assisted me. I also wish to thank Dr. John Andrews; Brenda Baylor Coulter and Sally Turner Baylor (who both compiled the list of school principals); Henry Coulter; Colin Dale for his help on the railroad information; Elizabeth Ehrbar of both historical museums; Jered Jackson; Molly Jubitz of the Cedar Key Public Library; Frances Hodges of City Hall; James Hoy of the *Cedar Key News*; Dick Martens of the Curmudgeonalia Book & Gift Shop; Leslie Sturmer; and Louise Tebo.

Before 1800

TOPOGRAPHY

At the western edge of Levy County are a dozen islands that make up the Cedar Keys National Wildlife Refuge, encompassing about eight hundred acres of wetlands, forests and islands in the Gulf of Mexico. They began as huge sand dunes when the glaciers receded across North America thousands of years ago, and eventually became rich breeding grounds for thousands of birds. Their thick foliage and many trees have enabled the islands to act as buffers for Cedar Key and the mainland during the many storms that have pounded the west coast of Florida. The tallest island is Seahorse Key, rising fifty-two feet above sea level, the highest point on the Gulf Coast.

The Lower Suwannee National Wildlife Refuge, off State Road 347 to the north of Cedar Key and veering off from State Road 24, is one of the state's largest protected habitats and nesting areas for American eagles, bald eagles, falcons, migratory birds, swallow-tailed kites and wading birds. Bird-watchers can see over two hundred species of birds there, as well as alligators, deer, hogs, wild turkeys and other wildlife. Workers built a bat house in the refuge in 2002 for more than 150,000 bats to roost before their nightly foray seeking out insects to eat. That has kept the annoying mosquito in some control, but visitors to the scrub and to the offshore islands should take along insect repellant. The Cedar Key Scrub State Reserve has trails through habitat areas reserved for the rare and endangered Florida scrub jay.

NATIVE AMERICANS

Archaeologists who have studied the early peoples of Florida tell us that Native Americans lived on the Florida peninsula for more than twelve thousand years, as evidenced by spear points and arrow tips found throughout the state, including Levy County. At that time, Cedar Key was probably eighty miles inland from the Gulf of Mexico, and Florida was twice as large as it is today, but rising sea levels shrank the coast dramatically.

At first, the Native Americans lived near water, whether freshwater streams and springs or saltwater bays along the Gulf of Mexico and the Atlantic Ocean. They adapted well to their environment, relying on fishing, hunting and farming to obtain food and raise their families. Their villages were probably small at first, a factor which would enable them to feed and clothe their families with the limited fish they could catch, crops they could grow and animals they could hunt. Little by little, they would trade with other tribes to obtain goods and products not available in their local areas.

The piles of trash that the Native Americans accumulated from decades of living in a place are called middens. When the Native Americans threw away the shells after eating shellfish, they threw them into piles—rather than spreading them around—in order to keep their living space free of shells. Although many of those middens have been destroyed by developers and road builders, enough middens remain to give clues as to how and where the Native Americans lived. The Shell Mound Archaeological Site on County Road 326, about nine miles north of Cedar Key, is a protected site that has long been a popular place for visitors to marvel at the height and size of such mounds. There is also a Native American mound at the Lions Club on the northwest corner of Sixth and F Streets in Cedar Key.

The Cedar Key State Museum on Museum Drive and the Cedar Key Historical Society Museum have more information about the Native Americans who lived in the area. The earliest Cedar Key inhabitants, those who lived there twelve thousand years ago, did not build Shell Mound. Instead, more recent peoples built it up some time between 500 BC and AD 1000. The five-acre mound, which is mostly covered with thick underbrush today, is made of discarded oyster shells and may have been deliberately built up in order to give the Native Americans a platform from which they could see the surrounding area and maybe act as a windbreak from storms.

The only archaeological digging at the site, done in 1959, went down just ten feet and found artifacts dating back to 500 BC. The twenty-eight-foot-tall mound probably holds many more artifacts, but archaeologists say that the mound was not a burial site or a temple mound. Some think that Hog Island, which can be seen from Shell Mound, may have been the burial site for the Native Americans in the area, but much of Hog Island is now marshland and belongs to the Lower Suwannee Wildlife Refuge.

Although archaeologists have not yet found any evidence of large towns in the area, the many artifacts found through the years, as well as the presence of several large Native American mounds, give tantalizing clues to a culture that may have flourished there for a long time. The people may have been part of what archaeologists call the Deptford Period (500 BC to AD 200) or the Weeden Island Period (AD 200 to AD 1000).

The tribe that probably lived in the area of the Cedar Keys was the Timucua, one of the largest groups of Native Americans in Florida at the time of the Spanish arrival in the sixteenth century. Although the estimated 150,000 Timucua in Florida in the sixteenth century fought battles with each other, they had a similar language and set of beliefs. The Native Americans were eventually killed by European diseases, slavery and deportation, and they have left behind few memorials, but the mounds, or middens, are testament to their having been in Florida for hundreds of years. The huge mound at the

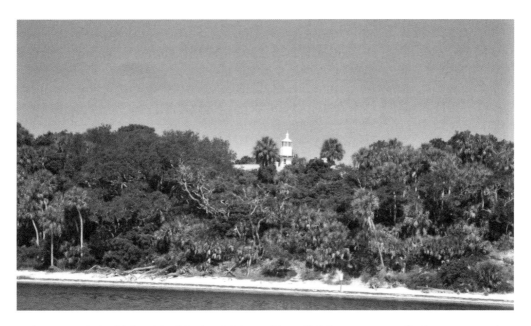

Seahorse Key is the highest island in the vicinity and has a lighthouse on top of it. *Image courtesy of Kevin M. McCarthy.*

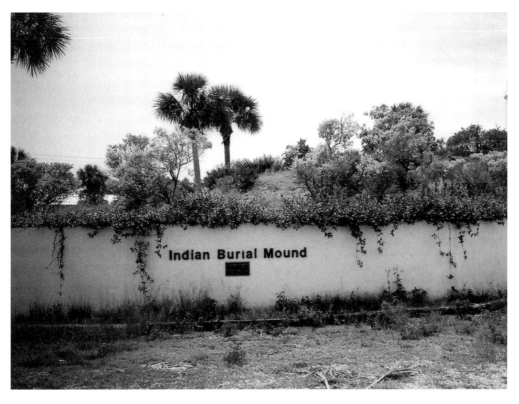

An old Native American mound near the Lions Club testifies to the presence of Native Americans hundreds—and even thousands—of years ago. *Image courtesy of Lindon Lindsey.*

The Seminole who remained in Florida have prospered. *Image courtesy of Florida State Archives.*

Crystal River State Archaeological Site in Citrus County, south of Cedar Key, is one of the most impressive in the state.

When a tourist accidentally discovered a human skeleton on Atsena Otie Key around 1999, scientists determined that the human remains were of a male buried over two thousand years ago on the island. Sensitive to the feelings of Native Americans, who are very protective of such finds and do not want them displayed for the public to gawk at, authorities reburied the skeleton at a secure site.

THE EUROPEANS ARRIVE

In the sixteenth century, Spanish explorers, including Hernando de Soto, led large forces of soldiers through the land to the east of Cedar Key, capturing and killing the Native Americans—for example, the Timucua, who had a large village at Long Pond, south of present-day Chiefland. There is no record that the Spanish made it to the Cedar Keys area on their trek north to the Tallahassee area, but their ships passed offshore and their troops marched inland.

Catholic missionaries established missions from St. Augustine over toward Tallahassee, but there is no evidence of such places in the Levy County area. Such missionaries were part of the colonization efforts by the Spanish, who established St. Augustine in 1565, a year after the French had tried—but failed—to establish a foothold on the St. Johns River. The Spanish controlled the territory of Florida for the next 250 years, except for a 20-year rule by the British between 1763 and 1783.

SEMINOLES AND EX-SLAVES

By the end of the eighteenth century, diseases, battles and deportations had taken a heavy toll on the Native Americans, who had been living in the Florida peninsula for thousands of years. Archaeologists estimate that the number of Florida Native Americans decreased from several hundred thousand to just several thousand by that time. Because there were relatively few Native Americans in Florida in the last part of the eighteenth century, Native Americans from Georgia and Alabama began migrating south to raise their families, grow crops and establish new villages. The Spanish encouraged that migration because they needed more Native Americans there to work the fields, build Spanish towns and join with them as allies against their enemies like the British and French.

The new settlers in Florida became known as Seminoles, from the Spanish word *cimarrone*, meaning "wild ones" or "runaways." Black slaves joined them after escaping from the harsh life on plantations north of Florida. In many cases, the Seminoles welcomed the runaway slaves, realizing that the ex-slaves could help them communicate with the whites, whose language the slaves had learned. The blacks also knew the latest farming methods, which they had learned on the plantations.

1800–1849

ARRIVAL OF WHITE SETTLERS

The lack of control by Spain over her Florida land led to much disorder, including that fomented by the British, who were secretly supplying the Native Americans with guns with which to fight the Spanish and Americans. In 1814, General Andrew Jackson—leading a force of Tennessee militia, Cherokee warriors and U.S. regulars—fought a large band of Creeks in Alabama, killing eight hundred of one thousand Native Americans. Jackson pursued the surviving Creeks to a site near present-day Montgomery, Alabama, where they surrendered. In the First Seminole War, President James Monroe ordered Jackson in 1817 to lead a campaign in Georgia against the Seminole and Creeks, as well as to prevent Spanish Florida from becoming a refuge for runaway slaves.

Jackson probably exceeded his orders in his Florida campaign, but he knew that many, if not most, Americans wanted control of the Florida peninsula. The troops burned down Seminole villages and their crops, captured Pensacola from the Spanish, caught and executed two British subjects (Robert Ambrister and Alexander Arbuthnot) who had been in cahoots with the Native Americans, and effectively took control of Florida. In 1819, by terms of the Adams-Onís Treaty, Spain ceded Florida to the United States in exchange for the American renunciation of any claims on Texas. Jackson became the first territorial governor of Florida and later president of the United States. During his presidency (1829–1837), thousands of Native Americans were removed from the South, including Florida, to reservations in the West.

With many Native Americans gone from North Florida, more and more white settlers, some with their slaves, migrated to the area to fish, homestead, raise crops and raise their families. The opportunities were there for hard workers, who prospered in the temperate climate and little by little attracted more settlers.

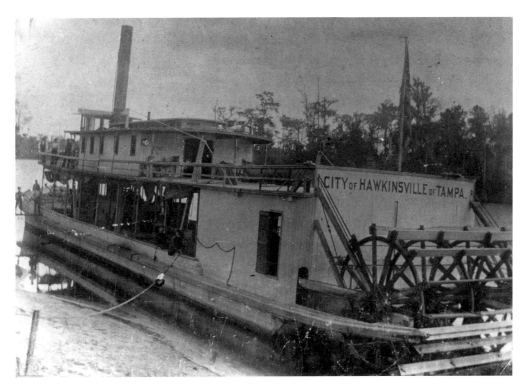

The *City of Hawkinsville* was a steamboat that ran from Cedar Key up and down the Suwannee River. *Image courtesy of Florida State Archives.*

STEAMBOATS

Before railroads and roads were built in Florida, steamboats were a main means of transportation, especially as a way to reach coastal ports and those towns and settlements on the inland waterways. Merchants used steamboats to take goods to and from many places in Florida, and travelers used them to go from place to place. The fact that three of the major rivers of the peninsula—St. Johns, the Apalachicola and the Suwannee—ran north-south enabled steamboats to cover much of the territory.

Beginning in 1834, steamboats began navigating the Suwannee just north of Cedar Key, at first sticking to the lower river below Branford, but later venturing as far north as Columbus, now a ghost town in Suwannee River State Park. One particularly bold pilot, Captain James Tucker, once used the swollen Suwannee to take his steamboat, *Madison*, up as far as White Springs, thus making the river navigable at certain times of the year from its mouth at the gulf to White Springs. During the Second Seminole War (1835–1842), the river had some forts and camps that steamboats serviced. Also, the sawmills and turpentine camps that sprang up along the river's banks needed groceries, hardware and clothing from Cedar Key.

As markets grew upriver, especially cotton, pilots would take their steamboats up from Cedar Key, where they would unload cargo from ocean-going vessels for the trip on the

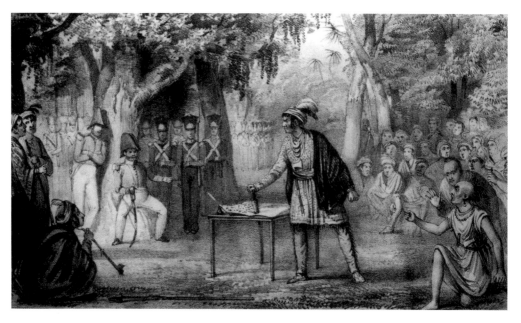

The action of Osceola, an influential Seminole leader, putting a knife through a treaty, signaled the start of hostilities. *Image courtesy of Florida State Archives.*

Suwannee. The river could be very tricky to navigate, especially around the rocky shoals upstream, and the wrecks along the way testify to those pilots who were careless.

SEMINOLE WARS

The Native Americans who were still in Florida in the first half of the nineteenth century deeply resented the intruders, especially those who claimed as their own land that which the Native Americans had been living on for centuries. When the Native Americans resisted the newcomers with force, the federal government sent troops to quell the revolt, suppress the Native Americans, kill or capture as many as possible and ship the live ones to Indian Territory in the West. Three major wars were fought with the Native Americans: the First Seminole War (1817–1818), the Second Seminole War (1835–1842) and the Third Seminole War (1855–1858).

After General Zachary Taylor became commander of federal forces in Florida fighting the Seminoles in 1838, he established over fifty forts and camps and built or improved over eight hundred miles of roads, including bridges and causeways. In order to distribute his troops as evenly as possible, he divided North Florida into twenty-square-mile sections, with each section to be guarded by a fort numbered according to the map showing all the forts. Fort Number Four in the Cedar Keys was manned by troops from 1839 through 1841. Later the term "Number Four" was used for a boat channel there, a railroad station, railway trestle, highway bridge and voting precinct.

Federal officials built a hospital and base on Depot Key (later called Atsena Otie Key) south of Way Key (where Cedar Key would later be located) and used it as a military depot (thus its name of Depot Key) and hospital between 1839 and 1842. It was on Depot Key that Colonel William J. Worth declared an end to the Second Seminole War in 1842, an action that allowed federal troops to leave the territory and go home. The staging area for both troops and Native American prisoners was on Seahorse Key.

Toward the end of the Second Seminole War, Seahorse Key had a temporary encampment, Cantonment Morgan, which consisted of a series of temporary buildings for receiving and deploying troops, caring for sick troops and Native Americans and housing captured Native Americans before they were shipped to the West. The location of Seahorse Key was advantageous from a health point of view, as the sea breezes alleviated the effects of the summer heat. While the cantonment was used in the early 1840s, a tornado or hurricane in October 1842 destroyed the buildings, although no one was seriously injured or killed. Among the soldiers stationed in the Cedar Keys in the 1840s was Lieutenant John Harvie, a West Point graduate who died of malaria there in 1841. He was honored in the naming of Fort Harvie in what later became Fort Myers in southwestern Florida.

Armed Occupation Act and Settlement Act

As the Second Seminole Indian War came to a close in 1842, with the removal of over three thousand Native Americans to the West and the allowing of about three hundred to escape to the Everglades, Congress passed the Armed Occupation Act and Settlement Act in 1842 to lure settlers to Florida. The act stipulated that any settler who would build a dwelling, cultivate five acres of land, live there for five years and protect it from the Native Americans would receive 160 acres of land. That act did much to attract settlers to the western part of the Florida peninsula in what became Levy County.

Hurricane of 1842

On October 4, 1842, a strong hurricane hit the Cedar Key area, blew strongly for two days and devastated much of Depot Key (later called Atsena Otie). The Native Americans in the area, according to a report by Captain John T. Sprague, considered the storm an omen of misfortune from the Great Spirit and would no longer go to the island. From then on, soldiers took the Native Americans to Fort Brooke in Tampa, from where they would be deported west. The hurricane raised the water twenty-seven feet up Depot Key, forcing the inhabitants to the center of the island, where the hospital stood, but the wind blew the building off its foundation. The storm destroyed several vessels in the harbor and wrecked the three-hundred-foot-long wharf. It also destroyed other buildings on the island, and residents had to tie themselves to trees to avoid being swept to sea. It would not be the last time that a hurricane would devastate that place.

AUGUSTUS STEELE

Of those who took advantage of the Armed Occupation Act and Settlement Act of 1842, the one who would have the greatest impact on the Cedar Keys was Augustus Steele, the U.S. customshouse officer for Hillsborough County and postmaster for Tampa Bay. In 1843, Steele went to Cedar Key, where he applied under the Armed Occupation Act of 1842 to take possession of the 169 acres of Depot Key, which he renamed Atsena Otie Key. Scholars have not yet determined the meaning and origin of the name of Atsena Otie Key. The meaning may have been "cedar island" from the Seminole language. The name is pronounced "aSEEna Otee."

A hurricane had recently destroyed much of the island, but Judge Steele planned to use its deep-water facilities for shipping out cotton, lumber, sugar and tobacco from inland plantations. In 1843, he paid $270 for all the buildings on the island and built summer cottages there for affluent clients, including David Yulee. In 1843, Steele established a town, which he called Cedar Key, on Atsena Otie. In 1859, he had it incorporated as the town of Atsena Otie to distinguish it from Cedar Key, which was being established on Way Key by the Florida Railroad Company. The towns remained separate—although the post office was moved to Cedar Key and the address was Cedar Key(s)—because several of the islands were inhabited at that time. In 1945, the post office was changed to Cedar Key (singular) because by then Way Key (Cedar Key) was the only one that was still inhabited.

In 1844, Steele became the U.S. collector of customs of the ports of Tampa and Cedar Key, a post he held until Florida seceded from the Union in 1861. In 1845, the same year that Congress admitted Florida to the Union, he was appointed the first postmaster of Cedar Key, which was then centered on Atsena Otie.

In 1846, Augustus Steele married Elizabeth Coddingham, an Irish-born Roman Catholic, and they had one child—a daughter, Augusta Florida Steele. She was born on Atsena Otie in 1847 and was educated there by tutors, including one well-known musician-composer, a man named Lignoski, who wrote a number of songs dedicated to Judge Steele. Another tutor for Judge Steele's daughter was author Ryder Randall, and it was there that Randall wrote "Maryland, My Maryland."

DAVID LEVY YULEE

If, according to local historian Charles C. Fishburne Jr., Augustus Steele was the father of Cedar Key, then David Levy Yulee was the town's stepfather because of the railroad he brought in. Yulee had one of the most unusual backgrounds of any Florida leader. Born in 1810 on the island of St. Thomas in the Virgin Islands, then under control of Great Britain, David was thus a British citizen. The young Jewish boy's father, Moses Levy, a businessman with ties to Cuba, moved to the United States around 1819, when Spain ceded Florida to the U.S.

At one point, he had the legislature change his name from David Levy to David Levy Yulee. Soon afterward, he married the daughter of Charles Wickliffe, former governor

of Kentucky, and the U.S. postmaster general under President Tyler. In the 1840s, Yulee began acquiring and developing a five-thousand-acre plantation on the Homosassa River south of Cedar Key. He realized that as Cedar Key prospered with the coming of the railroad, his sugar plantation would do well as it shipped out products via the gulf to the railroad terminus. He had slaves build a mansion on his island in the Homosassa and used eighty slaves to operate his plantation. With sugar-making machinery that he added in 1851, his output of raw sugar reached 185,000 pounds a year, and he was able to market 90,000 pounds of sugar.

Yulee argued against the emancipation of slaves and for the expulsion of Native Americans from Florida and also advocated the acquisition of Cuba by the United States for political and commercial reasons. Although voters chose Stephen Mallory to succeed Yulee in the Senate, Yulee used his connections in Washington, D.C., and Florida to push forward his cross-Florida railroad idea.

1850–1859

CEDAR KEYS LIGHT STATION/LIGHTHOUSE

In the 1840s, Cedar Key had become a major shipping port for cedar, cypress, pine, rosin and turpentine. Ships also stopped there to replenish their freshwater supplies. The depth of the harbor there induced entrepreneurs—for example, pencil manufacturers who harvested the many local cedar trees (*Juniperus siliciola*) into slats to be shipped north to pencil manufacturers—to plan expansion of their facilities, and navigators began petitioning the federal government for a lighthouse to protect the ships entering and leaving the harbor. In 1850, Congress appropriated eight thousand dollars for a lighthouse on Seahorse Key, adding another four thousand dollars two years later.

One of the men who designed the lighthouse there was Lieutenant George Meade, who would later lead the victorious troops that defeated Confederate troops at the Battle of Gettysburg. Meade worked with the Topographical Engineer Corps of the U.S. Army in designing lighthouses, including some of the structures in the Florida Keys. In 1854, workers built the brick structure on Seahorse Key on granite rock pilings and later added wooden-frame housing wings on each side of the brick tower for the lighthouse keepers and their families. The rectangular building had a spiral staircase—in the middle of the structure—that led up to the lantern room. The light was twenty-eight feet high, which is actually about seventy-five feet above sea level, and had a fourth-order fixed light visible for fifteen miles. William Wilson Sr. became the first keeper in 1854.

AUGUSTUS STEELE AND DAVID YULEE

In 1850 and again in 1852, Judge Augustus Steele was elected to the state legislature from Levy County. That position enabled him to lobby for a cross-Florida railroad to Cedar Key, a place that steamboats were calling at on their way between New Orleans and Key West and Havana. In 1852, he joined David Yulee to lobby for a railroad to

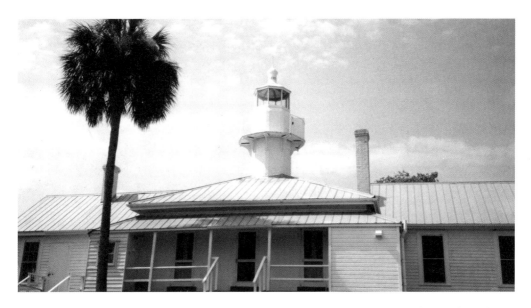

The Cedar Keys Light Station/Lighthouse is squat, but because it sits high on a hill, is easily visible from a great distance in the Gulf. *Image courtesy of Lindon Lindsey.*

Cedar Key, arguing against Governor Thomas Brown, who wanted a railroad to go to St. Marks. In 1854, Yulee returned to the U.S. Senate when the General Assembly of Florida voted to replace Jackson Morton, who had resigned.

The completion of the lighthouse in 1855 helped make Cedar Key a safer harbor, and that helped convince authorities of the necessity of a railroad there. In 1859, the Florida legislature passed an act to incorporate the city of Atseena Otie (the way it was sometimes spelled).

Churches

Cedar Key United Methodist Church traces its beginnings to 1855 and 1856, when minutes of the Methodist Episcopal Church, South, Tampa District mentions it, although there were no church buildings yet. The church was founded in 1855 on Atsena Otie, and the first church building was built in 1857 and 1858, according to a book written by a Methodist circuit rider, Reverend Jeremiah Rast, whose mission included all of Levy County and parts of Alachua and Marion counties—twenty-seven preaching stops in all. The members of the congregation built the present building in 1889.

The Railroad

One of the events that almost transformed Cedar Key into a major port was the completion of David Levy Yulee's cross-Florida railroad from Fernandina in the

The end of the railroad line in Cedar Key is now a raised embankment that is part of a trestle trail. *Image courtesy of Kevin M. McCarthy.*

northeastern part of the state to Cedar Key in 1861. He had incorporated the Florida Railroad Company in 1853 and began construction of a rail line two years later. The Florida Railroad ran for 155.5 miles, from Fernandina through Baldwin and Gainesville to the Gulf of Mexico. Such a line, which connected two deep-water ports on either side of the peninsula, would make unnecessary the long, dangerous and expensive trip around the Florida Keys. The timing of its completion, however, was disastrous.

As U.S. senator, Yulee did much for the new state of Florida and, of course, himself. For example, he succeeded in convincing Congress to pass an act in 1856 granting the state one and a quarter million acres of federal lands. Yulee's railroad had a federal land grant of 290,000 acres and a Florida grant of 505,000 acres. To finance the building of the railroad, Yulee obtained backing from northern brokers, a situation that would not continue when the Civil War started.

In 1855, Yulee had workers begin building the railroad on the eastern coast and by 1856 had completed the first ten miles. As more and more miles of track were added, train service began extending to inland towns. The financial panic of 1857, which affected much of the country, threatened the progress of the track laying, and Yulee's railroad company faced bankruptcy, but he was able to convince northern backers to pour more money into the enterprise. He spent much time writing and giving speeches to different groups on the commercial potential of the railroad. He argued effectively that to be able to move products from one side of the coast to the other in one day would greatly reduce the cost of transportation.

For the western terminus of his railroad, Yulee acquired much of the land on Way Key and established what came to be known as a "company town," which is not an

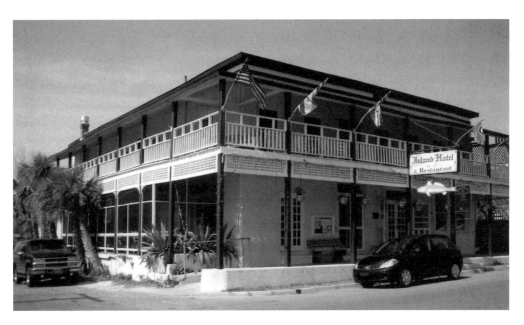

The Island Hotel would withstand many storms over the years. *Image courtesy of Kevin M. McCarthy.*

official town incorporated under the laws of Florida (which could put strict restrictions on an enterprise like a railroad), but a facility dedicated to the railroad. The 1859 town plan had a street grid for what would be the city of Cedar Key.

Senator Yulee became chairman of the Senate Post Office Committee (1855–1861), a position that enabled him to win mail contracts for his railroad from shipping companies that delivered the mail to Florida. His Florida Railroad received five hundred thousand dollars each year for its services as part of a tri-weekly mail service between New York and New Orleans by way of Fernandina and Cedar Key. He helped establish mail links between Cedar Key and Havana, as well as daily steamer service between Fernandina and Charleston, South Carolina.

The Island Hotel in Cedar Key was built in 1859 from seashell tabby with oak supports. Workers built the ten-room building from hand-hewn cypress boards covered with tabby, a mixture of crushed oyster shells and lime rock. They made the walls ten inches thick and used large twelve-inch oak beams to support the wooden structure. Over the years its wooden floors have sagged a little, but it has withstood many hurricanes and still has an amazing charm. In the beginning it served as a general store and post office.

The Parsons and Hale General Store, the oldest commercial building in the town, had foundations of brick and wood piers and may have been the only building in the town that had a basement. The location of the store was ideal since in those days all merchandise for the town arrived by water, and supplies for the store could be unloaded from a boat at the back of the facility.

Major John Parsons and his partner and co-owner Francis E. Hale hoped to take advantage of the economic opportunity when they opened Parsons and Hale General

Store. During the Civil War, Union troops may have used the facility as a barracks and warehouse as the Confederates also did, since its owner, Major Parsons, was commander of a detachment of Confederate volunteers defending the Gulf Coast against federal gunboats and troops. After the war, Parsons and Hale reopened their general store and sold a wide variety of goods, from agricultural equipment, building supplies, dry goods, fuel oil, furniture, groceries, hardware and naval stores. The two men were also shipping agents and were involved in the fishing and turtle business. Offices of the customshouse and the Cedar Key Post Office were also located in the general store during that period. The facility began taking boarders and selling meals some time in the late 1800s, although the downstairs area continued to be used for commerce. The 1896 hurricane severely damaged the facility.

1860–1869

CEDAR KEYS LIGHT STATION/LIGHTHOUSE

At the beginning of the Civil War, Confederate sympathizers extinguished the light in the lighthouse in order to hinder Union forces that were blockading the coast. Yulee's Florida Railroad took the station's sperm oil in order to keep it out of the hands of Union raiders. Federal forces that occupied the island in 1862 used a cemetery there for the final resting place of sailors stationed there and for Catharine Hobday, the mother of one of the lighthouse keepers.

In 1866, after the Civil War, engineers again lit the light, which resumed helping ships using the Cedar Key port, and N.J. Collier was appointed the light keeper. The following year, he was removed from the post, and the assistant keeper, Henry Selner, took over at an annual salary of $450. Henry married Hariett Turner that same year in Cedar Key, and the two of them moved into the four-room lighthouse and lived on the island until October 1868, when they left to take up farming in Hillsborough County, Florida.

The station was discontinued in 1915. Catharine Hobday, of Seahorse Key, the mother of keeper Andrew Hobday, may have been the only female lighthouse keeper of the Cedar Keys Light Station, serving there from September 16, 1872, until her death on November 30, 1879.

The lighthouse is open several days a year for visitors, who can dock private boats on the island or take shuttle boats from Cedar Key. The island is usually closed from March 1 through June 30 because of the fragile nature of the breeding nests for the birds that live there. At that time, boats are not allowed within three hundred feet of the island. Colonial water birds tend to build their nests very close together in colonies, and in fact, often build their nests at the same time, lay their eggs at the same time and sleep at the same time. They also return to the same island each year and are very susceptible to changes in the environment, for example with any pollution of the nearby lagoon or increased danger from predators.

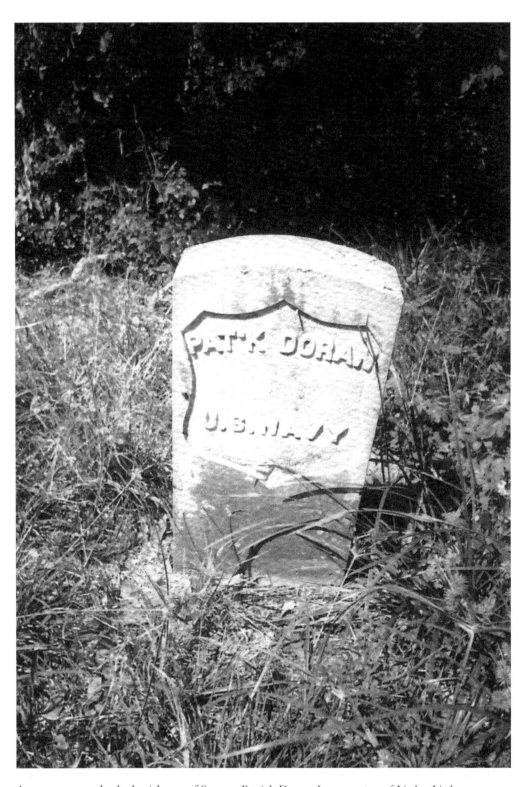

A gravestone marks the burial spot of Seaman Patrick Doran. *Image courtesy of Lindon Lindsey.*

Augustus Steele

In 1860, local electors voted to send Augustus Steele as one of the representatives of Levy County to the Florida Secession Convention, which voted to have the state join other Confederate states in withdrawing from the Union.

Newspapers

The county's first newspaper may have been the *Telegraph*, which first appeared in January 1860 in Cedar Key. Its owner, Charles W. Blanchard, and its editor, E.M. Graham, published the paper each Saturday. Because present-day Levy County was part of Alachua County until 1845, the area was covered by the *Florida Dispatch of Newnansville* before the split.

The Civil War

At the start of the Civil War, about one hundred people lived in the Cedar Key area, mostly on Atsena Otie and Way Keys. Just as the railroad line was finished in 1861, the Civil War threatened its destruction. In January 1862, federal troops from the USS *Hatteras* out of Key West occupied Cedar Key, captured three sloops and five schooners in the harbor, burned down the railroad station, destroyed the wharf and several boxcars of military supplies, demolished a turpentine storehouse and cut the telegraph wires. The town, which an officer and only twenty-two Confederate soldiers were trying to defend, had seen the removal of two companies of troops to Fernandina at the other end of the railroad to meet the anticipated Union attack there. When that attack did take place in March 1862, David Yulee fled on the last train out of Fernandina, headed for Gainesville and ordered the bridges behind him burned. Confederate troops later took up the rails of part of the Florida Railroad to use them elsewhere and destroyed the railroad, at least for the time being. Two years later, another group of federal troops landed at Cedar Key, tore up more of the tracks, burned a bridge over the Waccasassa River and effectively took Florida out of the war.

The one product that locals could make at the beginning of the Civil War was salt, which was used for packing pork, beef and fish for shipment and storage. Salt making was so important in the Civil War that those working at the salt works were exempted from military service. The Cedar Key Confederate Salt Works located near Fort Number Four had sixty kettles that altogether could produce 150 bushels of salt a day. In October 1862, the Union raiding party destroyed those facilities. Visitors to the Cedar Key State Museum can see a seven-foot-wide black kettle that was used for the making of salt at that time.

In 1863, just before the Union blockade of Cedar Key, Judge Steele took his family from Atsena Otie to Gainesville for safety. According to Sara Matheson, Steele's

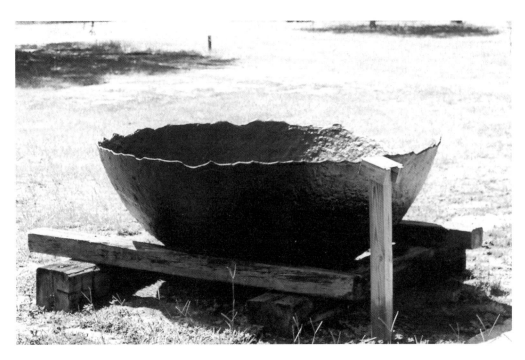

This authentic salt kettle can be seen outside the state museum in Cedar Key. *Image courtesy of Kevin M. McCarthy.*

granddaughter-in-law, he died in Wellborn, Florida, and is buried with his wife in Gainesville's Evergreen Cemetery. His daughter married James Matheson in 1867, and they had a son, Chris.

Among the Union troops stationed in the Cedar Keys was Company E of the U.S. Colored Troops Infantry. They were there from February 1864 until December 1864.

During the Union blockade of Florida's coast during the Civil War, enterprising blockade runners would use the shallow waters of the Suwannee to load cotton, take it downstream and attempt to escape the Union ships offshore. Sometimes they succeeded; sometimes they did not. The most famous steamboat wreck of the Suwannee is the *Madison*, a vessel that was scuttled in Troy Springs above Branford in 1863 to keep her out of Union hands. In the years that followed, local residents cannibalized the wreck for lumber to rebuild their homes and farms, and workers may have taken her boilers to Cedar Key to help make salt.

The Florida Railroad was reorganized many times after the war and merged with other lines, eventually becoming the Seaboard Air Line Railway in 1900. Union troops burned much of Yulee's sugar-making plantation in the Homosassa River. There was also a skirmish at Number Four Station in February 1865 that involved the skilled Confederate commander, Captain John J. Dickison, but that Confederate victory did nothing to change the outcome of the war. One of the local soldiers engaged in that skirmish was Captain Edward J. Lutterloh, Yulee's local representative for the Florida Railroad through Yulee's company, the Florida Town Improvement Company. In 1984,

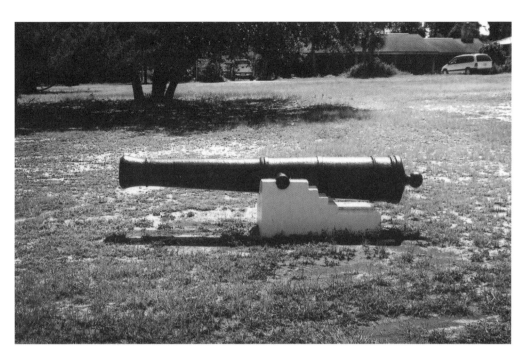

A Confederate cannon is on display outside the state museum. *Image courtesy of Kevin M. McCarthy.*

Civil War buffs reenacted the battle where State Road 24 and the Number Four Bridge intersect.

Captain Lutterloh was the namesake of "Lutterloh's Ditch," the body of water that Confederate sympathizers used under cover of darkness to deliver supplies to hidden Confederate forces working the salt-making facilities there. In 1864, the Cedar Keys became the headquarters of the Second Florida Cavalry of the Union Army.

After the Civil War, Yulee was charged with treason and imprisoned at Fort Pulaski, Georgia. President Ulysses Grant eventually ordered the release of Yulee, who went to live in Washington, D.C., with a married daughter before dying in New York in 1886. He is honored in the naming of Levy County and the town of Yulee in Nassau County.

The house on the northeast corner of G and Fourth Streets, called the Old Block House, may be the oldest building in Cedar Key and also the former headquarters of the Union army during the Civil War, although the latter claim has not been verified. Parsons and Hale, who also built the General Store and warehouse that became the Island Hotel, supposedly built the Old Block House using tabby, a mixture of crushed oyster shells and lime rock. David Yulee's Florida Railroad Company originally owned the plot of land there, which they sold to Parsons and Hale in 1860. When workers were building the house, they dug out part of a Native American midden to allow the north and east walls of the house to back into the hill. After years of neglect, the house was rehabilitated in the 1960s.

JOHN MUIR'S VISIT

Famed naturalist and future founder of the renowned Sierra Club, twenty-nine-year-old John Muir (1839–1914), completed a thousand-mile walk from Louisville, Kentucky, to Cedar Key in just two months' time, arriving in the Florida town in October 1867.

From Fernandina to Cedar Key he had used the path of the Florida Railroad. Muir tried to work at a sawmill in the Cedar Key area but became very sick with malaria. Local sawmill owner R.W.B. Hodgson and his wife, Sarah, took Muir into their home and nursed him back to health. By January 1868, he had recovered enough to sail for Cuba and continue his long trip, which would have very beneficial results for the conservation movement in America. He later helped establish Yosemite National Park and the Sierra Club, one of this country's best-known environmental organizations. He served as the first president of the Sierra Club from 1892 until he died in 1914.

An account of that trip, *A Thousand-Mile Walk to the Gulf*, was published in 1916, two years after Muir's death. A plaque at the Cedar Key State Museum commemorates his visit. At least three others have retraced Muir's steps to Cedar Key, in 1984 and 2006.

RECONSTRUCTION

Florida slowly recovered after the Civil War. The state's population of 140,000 in 1860 reached 337,000 in 1885 and 752,000 in 1900 as more and more people moved to the peninsula to seek opportunities. In the Cedar Keys, Way Key superseded Atsena Otie

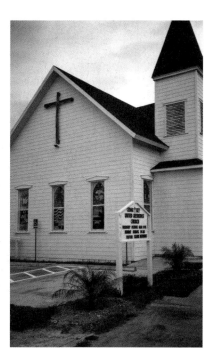

Right: The modern Cedar Key United Methodist Church is one of the oldest religious institutions in the town. *Image courtesy of Kevin M. McCarthy.*

Opposite: The Old Block House may have been the former headquarters of the Union Army during the Civil War. *Image courtesy of Kevin M. McCarthy.*

Key in terms of population growth and commercial development, especially as the railroad line had its terminal depot on Way Key. Many of the new residents in Cedar Key were African Americans, who would become a political force in the next decade.

In 1858, before the war started, workers had built the Eberhard Faber Mill on Atsena Otie to supply cedar slats to a pencil factory in New York. A larger mill on Way Key, the Eagle Pencil Company Cedar Mill, also cut cedar for pencil slats and shipped them to New York factories for processing into pencils. Other than possibly the Eagle Pencil Company, the mills did not produce pencils—only slats for the pencils, which were made elsewhere. In 2007, the Florida Society of American Foresters paid tribute to the role of Cedar Key in the harvesting of red cedars, pines and bald cypresses. The society unveiled a commemorative plaque near the Faraway Inn at 847 Third Street. The Faraway Inn was built in the early 1950s on the original site of the nineteenth-century Eagle Pencil Company Cedar Mill, which was damaged in the 1896 hurricane and storm surge.

After the war ended in 1865, workers repaired the railroad line and the shipping of commerce and passengers resumed from coast to coast. The western end of the railroad tracks was where the Captain's Table Restaurant is located now.

Florida Rejoins the Union

On July 4, 1868, civil government resumed in Florida, replacing the military that had been installed after the end of the Civil War. Three weeks later, on July 25, Congress declared that Florida was again in the Union after the people of the state had adopted

a new constitution and declared that the Ordinance of Secession was null and void. In April 1877, the new U.S. president, Rutherford B. Hayes, withdrew the last of the federal troops from Florida to end Reconstruction.

In 1869, officials incorporated the town of Cedar Keys. By 1870, the new town had a population of four hundred, many of whom began working in the fishing, green turtle and oyster industries. In January 1875, local residents J. Ira Gore and his brother, F.S. Gore, began publishing a newspaper, the *Florida State Journal*. Ira Gore continued as editor until about 1883 and was followed by Dr. R.H. McIlvane. The weekly newspaper stopped sometime in the 1880s. J. Ira Gore would later be the editor of the *Cedar Key Commercial* around 1890. Another weekly newspaper out of Cedar Key in 1893 was the *Gulf Coaster* edited by someone named Corr.

CHURCHES

One of the early members of Cedar Key United Methodist Church, Eliza Hearn, wrote in her diary in 1869 that "There are more heathens here than anywhere in the Southern States. We have need of a Missionary preacher here as much as China or other heathen Countries." She also wrote the following: "The men of this place [are] very wicked and they do not want any church. They would see virtue starve to death before they would help them to live. I am sick of hearing of this wickedness—I do not think Sodom or Gormor [sic] ever was as wicked. God have mercy on these people. I am afraid he will send some dreadful judgment on the place." Hurricanes in 1896 and 1950 damaged the church building, but the congregation managed to rebuild it each time. After the 1896 hurricane, the Bronson Methodist Church helped the local congregation rebuild their church.

When the Episcopalian bishop of the diocese of Florida, John Freeman Young, visited in 1868, he asked the Reverend B.C. Perry, who was serving the Episcopalians in Gainesville, to visit the Cedar Keys and hold services whenever possible. That request resulted in monthly services being held in a small building in town, a so-called "Union" church that all the denominations used. The Christ Episcopal Church in Cedar Key dates its beginnings to that visit in 1868.

RAILROAD

The heyday for the railroad after the war was the period between 1869 and 1884, when its freight cars carried pencil slats as well as other cedar material, pine and cypress lumber. There was heavy traffic in turpentine, palm fiber and brushes, as well as oysters, fish and sea turtles. The train carried fruits and vegetables for loading onto steamers at Fernandina for the trip north, as well as raw cotton and sugar from Cuba to refineries and mills of New England. Passengers arriving by boat from New Orleans and Havana would board trains for the cross-state trip on their way to places like Charleston, Philadelphia and New York.

The trains traveling from the east brought household goods, food and new immigrants seeking places to raise their families. The train had a schedule of two runs a day in both directions. The so-called "fast" passenger train took almost nine hours between Fernandina and Cedar Key in the 1880s, while the ordinary train took twelve or thirteen hours.

Yulee's resident manager in Cedar Key was a lawyer and local politician, Edward Lutterloh, a man associated with two long-lasting buildings in the town: the Lutterloh Building and the Lutterloh Store. The former, built around 1871 as a private residence for Lutterloh, became an army depot, a service station, restaurant, club, city library, gift shop and, most recently, a museum for the Cedar Key Historical Society. The Lutterloh Store was built in 1875 and functioned as a general merchandise and grocery store and a real estate office. In 1876, Lutterloh was the official who proposed the building of a road from Cedar Key to the mainland, but it would take a decade before it was finally built.

CHURCHES

For the Christ Episcopal Church, the winter of 1869–1870 turned out well, because the Reverend Mr. Van Linge and his family spent their winter in Cedar Key, holding services

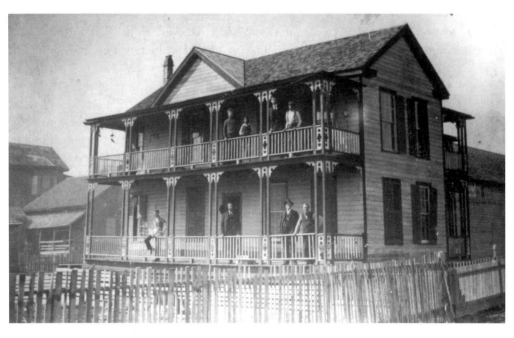

The hotel on Scale Key is no longer there. *Image courtesy of Lindon Lindsey.*

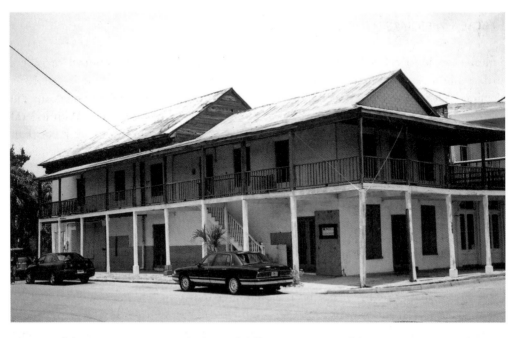

The Lutterloh Store on Main Street had several different uses over its lifetime. *Image courtesy of Kevin M. McCarthy.*

in a building on Second Street near the Cedar Mills. After he left in 1870, the Reverend Mr. Perry resumed the services until sometime in 1871. For the next two years, itinerant Episcopalian clergy would have services in the town.

Members of the church were pleased when, in 1876, the county sheriff put the so-called "Union" building on sale in a tax sale, and the local Episcopalians bought and refurnished it. It may have helped that one of the most powerful men in the town, E.J. Lutterloh, was an Episcopalian. The Reverend O.P. Thakara, who served the church in Fernandina, held services in the new church. He was followed by the Reverend Charles A. Gilbert, who became rector in Gainesville in 1877. That summer he encouraged the people of Cedar Key to organize a parish, which was done when eighteen people signed their names to the document that organized the Parish of Christ Church. The Reverend Gilbert served as rector until 1878, when he went to Key West to serve the church there. In 1879, the Reverend Meany once again became rector in Gainesville and divided his time between there and Cedar Key.

The Cedar Key First Baptist Church was founded in 1891 (according to the church itself) at the corner of present-day Fourth and E Streets at the home of Louise and Tom DeMeritt. In the early years the church shared ministers with the Baptist Church of Sumner and other small towns. Preachers would often preach in Cedar Key on the first and third Sundays and then preach elsewhere on the other Sundays.

Local Officials

Among the local officials were several African Americans—town council members Arthur Simmons and John G. Williams—which attested to the fact that in the 1873 election, thirty-two voters were black compared with twenty-nine white voters. In the 1874 election, voters elected a black mayor, marshal and three aldermen. With federal protection, blacks increased their proportion of registered voters from 52 percent in 1873 to 62 percent in 1874. The black mayor was John G. Williams. Other blacks elected to office were the marshal (F.E. Miller) and three aldermen (William Canty, Peter Hart and Jeff McQueen). As the painful era of Reconstruction ended, the dominant white businessmen of Cedar Key expanded the town council from five seats to seven in order to dilute the strength of those blacks who would win election to it. For the first time in a long time, whites outnumbered blacks, 111 to 90, on the list of registered voters. In the municipal election of 1877, no black was elected to any town office.

The most interesting electoral result that decade was the election of Edward J. Lutterloh to mayor in 1879, but he resigned later that year when he realized that he could not be the mayor as well as the representative of the Florida Town Improvement Company, David Yulee's railroad company. The town council, for example, spent much time trying to get Yulee to give land to Cedar Key for such essentials as a cemetery, but Yulee, who was living far away in Washington, D.C., continually refused to do so.

In 1886, Yulee's company finally deeded a cemetery to the town. Interestingly, several months later Yulee died and was buried in Georgetown Cemetery in the nation's capital.

Christ Episcopal Church, pictured here in the 1870s, was one of the oldest churches in Cedar Key. *Image courtesy of Florida State Archives.*

Edward J. Lutterloh would later become a very active local official and would be elected and re-elected several times to the post of mayor.

LOCAL BUSINESSES

By the fall of 1874, the town had three steam mills and six mercantile firms: Thomas Barnes, Max Blumenthal, W.H. Hale, E.F. O'Neil, Parsons & Hale and Willard & Roux. The Hale of the firm Parsons & Hale, Francis E. Hale, was elected mayor in 1875; he would serve as mayor or alderman for most of the rest of the nineteenth century. Before 1880, Hale built the F.E. Hale House, on the southeast corner of the intersection of E and Second Streets, which is occupied today by one of his descendants and is one of the best-preserved houses in Cedar Key.

In order to obtain workers for town improvements, the town council adopted an ordinance that required two days of street work or the payment of one dollar by every male between the ages of twenty-one and forty-five except "strangers, paupers, and insane or idiot persons." In 1877, officials changed that law slightly to say that every able-bodied male between the ages of eighteen and forty-five had to work for two 5-hour days on the streets or pay a five-dollar fine. Such a system provided cheap labor to

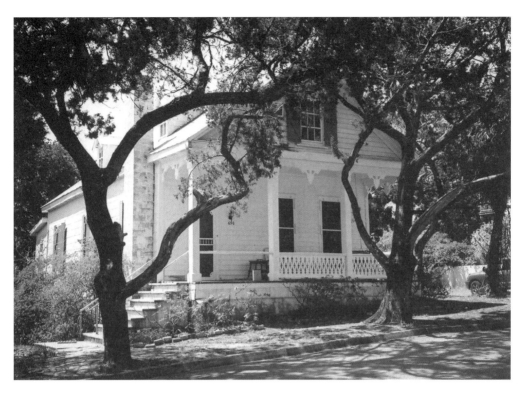

The Hale House on Second Street is one of the best-preserved houses in town. *Image courtesy of Kevin M. McCarthy.*

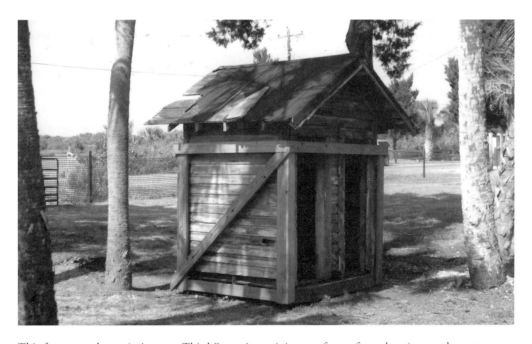

This former outhouse/privy near Third Street is reminiscent of ones from the nineteenth century. *Image courtesy of Kevin M. McCarthy.*

the town and also probably instilled pride in the community, as most men pitched in to improve the physical appearance of Cedar Key.

That same year, officials had workers build a small infirmary on Snake Key in order to quarantine those coming in on ships. This included people who were suspected of having cholera (after the Civil War) or yellow fever (in the early twentieth century). In 1878, officials also required that residents had to use privies. Anyone who refused would have a privy built for him. He would either have to pay for it to be built, or he would have to go to jail.

PEOPLE

In 1878, African Americans Charles Benson and Bully Wiley were once again elected to the town council.

EARTHQUAKE OF 1879

While most people do not think of Florida as being in an earthquake zone, several earthquakes have actually rocked North Florida. In 1879, an earthquake lasted ten seconds and sent people tumbling out of their beds and knocked dishes off their shelves from Cedar Key to St. Augustine to Tallahassee.

1880–1889

Henry Plant's Railroad

By 1880, when the South had weathered the difficult times of Reconstruction, entrepreneurs like Henry Flagler and Henry Sanford were heading to Florida for the opportunities it offered. Another Henry, Henry B. Plant, organized the Plant Investment Company and made plans to develop the state's west coast. Whether he planned to make Cedar Key his main west-coast port, as some historians have claimed, is debatable. The intention of the Internal Improvement Act was to build a line to Tampa with a branch to Cedar Key, and so one can argue that Cedar Key was to be just one of several ports on the west coast of the state.

Cedar Key was a good choice for a port because of its potential deep-water channel, its railroad terminal, accessibility of rich oyster beds to supply connoisseurs up and down the coast, a work force used to shipping millions of feet of cedar or cedar slats for the production of lead pencils, proximity to the Suwannee River and its entrée to the Georgia border, the many steamboats that called at the port, and—maybe most importantly—the fact that the successor to Yulee's Florida Railroad, the Florida Transit & Peninsular, already had a line across the state and was in financial difficulty. However, Plant discovered that ownership of the line would not include ownership of the terminal at Cedar Key, which the owners refused to sell him.

Whether Plant did or did not curse at the locals, "I'll wipe Cedar Key off the map. Owls will hoot in your attics and hogs will wallow in your deserted streets," he abandoned his plans for making the town his terminus and chose Tampa instead. He eventually established the Plant Steamship Line and carried passengers and freight down to Key West and on to Havana, Cuba. Plant's railroad to Tampa drastically cut down the rail traffic to and from Cedar Key.

In the end, Tampa was a better choice for the major port on the state's west coast, not only because of its deep-water port (which accommodated large ships much better than Cedar Key could have) but also because of Tampa's proximity to phosphate fields

(which needed a nearby port for shipping the raw material out) and its burgeoning cigar industry.

SCHOOLS

In the late nineteenth century, Eliza Hearn and her sister, Amelia Hearn, taught school to those white children whose parents could support the small facility. Another school was run by John F. Warren. In 1885, Cedar Key had two schools: Number Three for whites and Number Four for blacks. The town council voted that year to spend three hundred dollars a year total on the two schools, with equal amounts going to each facility at the rate of fifty dollars a month, provided that the schools were free to all students living within the city limits. Before Eliza Hearn died in 1910 at the age of eighty-one, she offered her beloved town the plot of land on which she had lived, provided that the town would care for her final resting place. That land became the site of the public school. Today one can visit her gravesite, along with that of her father (Captain Thomas Hearn, who died in 1866) and sister (Amelia, who died in 1885). The gravestone, near the Cedar Key High School, has their names and the simple statement: "lived here and supported public schools."

CHURCHES

At Christ Episcopal Church, Bishop John F. Young consecrated the facility in 1882 at a time when the congregation reached 114 members. Later that year, the Reverend William Willson became rector of the church and served it along with the outlying missions, for example at Rosewood and Bronson. Meanwhile, parishioners had the church building moved to the corner of Fifth and D Streets, its present site.

In 1886, Bishop Young died and was succeeded by the Right Reverend Edwin Gardner Weed, who sent the Reverend C.W. Arnold in 1889 to replace the Reverend Willson, who retired because of ill health.

An 1883 directory listed four groups under what it called "Societies of the Colored People": Bethlehem M.E. Church with Pastor Reverend Joseph Keller, African M.E. Church with Pastor Reverend W.W. Shell, Zion M.E. Church and the Baptist Church with Reverend Frank Danzy. The first-named church was probably the same as the African American Methodist Episcopal Bethlehem Church that dates back to 1874 and is located on the north side of Seventh Street between G and H Streets; the first official appointment there was of Reverend Issac (or Isaac) Johnson in 1874; the large, wooden church built there, with a parsonage behind, served a strong congregation that had as its pastor in the late 1880s Reverend A. DeBose. After a fire burned down that structure in the 1940s, the congregation built another facility, but the 1950 hurricane damaged that one. The present structure replaced it, but the dwindling congregation necessitated the sale of the building in 1972, and it became a private residence.

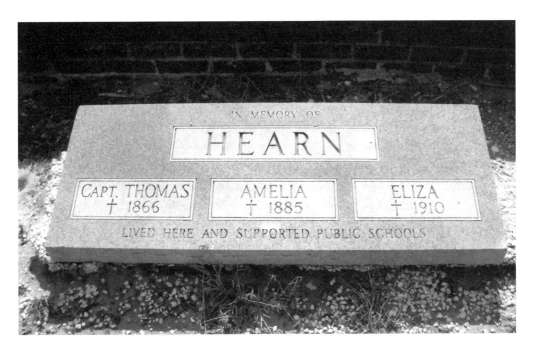

The Hearn gravestone near the high school honors three former residents who did much for the community. *Image courtesy of Kevin M. McCarthy.*

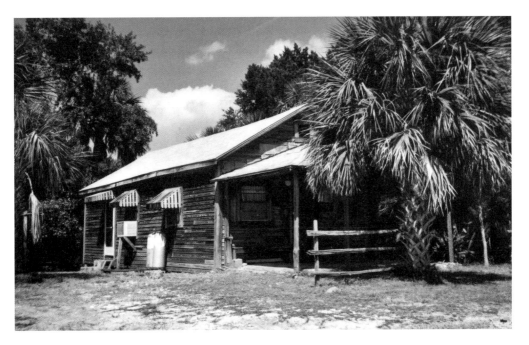

This building on the north side of Seventh Street is on the site of a former African American church from the nineteenth century that burned in the 1940s and was damaged in the 1950 hurricane. *Image courtesy of Kevin M. McCarthy.*

LOCAL ISSUES

The mayor and town council had among their many duties those of the Board of Health and were vigilant for any telltale signs of diseases like those brought in on ships. In 1881, they declared a quarantine to be in effect, probably with the advice of their port inspector, Dr. J.H. Roberts, whom they had picked over two other doctors: Owens and Thomas. One evening, while he was sitting by a window in his house, Dr. Roberts narrowly missed being hit by a bullet fired into his house through that very window. Although the town council offered a one-hundred-dollar reward for the arrest and delivery of the culprit to the marshal, no one turned him in. Soon afterward, Dr. Roberts left town for good.

One of the main topics of conversation among town officials and residents in the last two decades of the nineteenth century was the need for a road to the mainland, the extension of D Street by means of what people called the "Dirt Road." In 1882, residents voted to seek bonds for the construction of the road, indebting themselves in the hope that the road would lead to better contact with the mainland.

In 1885, the town council ordered a hook-and-ladder truck and two fire extinguishers in an attempt to establish a fire-fighting capability.

Voters unanimously chose William W. "Billy" Cottrell, an employee of the U.S. customshouse, as mayor in 1889, but he would end up being one of the most bizarre town officials ever. He used his office to harass people in the community, including his boss, the U.S. collector of customs. The new mayor's brother, E.L. Cottrell, defeated veteran town clerk N. Wooldridge by an astounding margin, ninety-nine votes to one, but then withdrew right before the swearing-in ceremony, at which point Mayor Cottrell appointed Wooldridge to another term in office, with no explanation of E.L. Cottrell's change of heart. At that point, Mayor Cottrell left town for two months without any explanation.

CEMETERIES

After town officials finally acquired land from David Yulee's company for a cemetery in 1886, they began using it for burials. Blacks could be buried in the town cemetery, but only in a segregated section. One recurring problem with the cemetery—one that was not solved until much into the twentieth century, with the building of an access road to the site—was that those attending burials at the cemetery could go only during low tide, since the road to it was over the flats, which were inundated at high tide. Until much later, when fees were charged for burial there, anyone could pick out a lot. As Bessie Gibbs said for a *National Geographic* article (November 1973): "You just go out there and stake a piece of ground, and it's yours."

Local historian Lindon J. Lindsey and others have carefully recorded the names and pertinent dates of those buried in that and other county cemeteries. Many of the Cedar Key notables who may have been buried there are nowhere to be found, for example

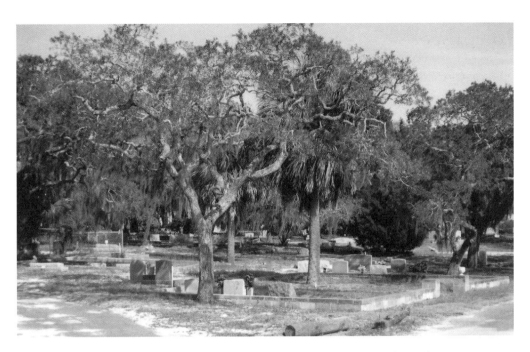

The main cemetery of the town has a beautiful setting amidst many trees and near the water. *Image courtesy of Kevin M. McCarthy.*

The cemetery on Atsena Otie, part of which has a metal fence around it, is still there. *Image courtesy of Kevin M. McCarthy.*

Edward Lutterloh, Yulee's local representative and a long-time official of the town. The burial site of his brother, John Brooks Lutterloh, also an official of the town, has been found, but not that of Edward.

According to Ms. Frances Hodges, clerk of the city of Cedar Key, the anchor at the entrance to the cemetery was found by a fisherman from Tarpon Springs. He was fishing for mullet off Cedar Key when he snagged the anchor and brought it in. He sold it to Phil Thomas for ten dollars, and it found its way to the cemetery.

The town has two other much smaller burial plots in addition to one on Atsena Otie and one on Seahorse Key. A small burial plot at the corner of SW 121st Street and SW 165th Avenue has half a dozen plots, five marked and one unmarked, five of them for infants. The so-called Bishop Cemetery (because most of the graves are of members of the Bishop family) on Rye Key dates back to the first decade of the twentieth century. And a walled-in plot at Cedar Key High School contains the final resting place of three people from the Hearn Family, which was associated with the early schooling of the town.

NATURAL DISASTERS IN THE LATE 1880S

The so-called Charleston Earthquake occurred in 1886. The *Florida Times-Union* out of Jacksonville had this description from Cedar Key: "August 31, 9 p.m.—Heavy and distinct earthquake shocks are being felt here. Houses and the earth are trembling violently and [rail]road cars standing on the side tracks here are moving. The inhabitants are excited. WAY KEY."

In 1886, a hurricane made landfall south of Levy County at Red Level and produced maximum winds of ninety-eight miles per hour. Two years later, a category two storm—with winds between ninety-two and ninety-eight miles per hour—hit the area between Levy and Dixie Counties just north of Cedar Key. The town was on the worst side of that storm, the south side, and bore the brunt of the heaviest winds and storm tides. The town would be on that same side of the devastating 1896 hurricane.

RAILROAD

By the end of the nineteenth century, a new line—the Atlantic, Gulf & West India Transit Railroad—connected Cedar Key by train to Gainesville and then to other parts of the state and nation. Train passengers could connect in Cedar Key by steamship to Pensacola, New Orleans, Key West and even Havana, Cuba. Those traveling by land could connect in Gainesville for Ocala and Tampa. The passenger line would continue to Cedar Key until 1932, but by then roads connected the town to others.

INDUSTRY

The shipping out of slats for pencils was supplanted by sponges and commercial fishing in the 1890s. In 1895, locals shipped out over three hundred thousand pounds of sponges, along with more than a million pounds of mullet.

CHURCHES

In 1891, at the Cedar Key United Methodist Church, the Reverend Francis R. Holman succeeded Reverend Arnold. Local economic conditions were so bad that the church had only ten families by 1895 and only seven the following year. After the 1896 hurricane and huge storm surge, the church could no longer support a full-time minister, so Reverend Holman moved to Starke, Florida.

Before the establishment of the Cedar Key Church of Christ, a congregation of New Testament Christians met in a house on the corner of Third and F Streets. One of the preachers who helped that church was Denison Mason, MD. That congregation ceased to exist in the late 1800s.

VIOLENCE IN THE TOWN

From time to time, violence broke out in and around the town, much as one might expect in a frontier settlement. For example, on one day in 1892, an unknown assailant ambushed T.R. Hodges with a gun, but missed the target by only a half inch. The next year, unknown killers bludgeoned to death boat builder Eugene Coons. The killers may have been sent by a New York company that had contracted with Coons to build a large schooner that might have become involved in gunrunning to Cuba; the schooner and men were never found.

CEDAR KEY GROWS AS A PORT

Registry records of the United States Bureau of Navigation for 1896 show that over thirty ships, schooners, sloops and steamers, some over one hundred feet long, used Cedar Key as their home port. A regular steamship line from New Orleans to Havana, Cuba, also used the town as its home port. Two thirds of those ships were built there. Prosperity seemed to be limitless. Local residents began changing their perception from "Town of Cedar Keys" to "City of Cedar Key." Many of them may have thought, "What could possibly go wrong?"

HURRICANES

On September 29, 1896, a hurricane accompanied by a ten-foot-tall tidal wave swept in from the sea and caused much damage, destroying the Eberhard Faber Mill on Atsena Otie, the Eagle Pencil Company Cedar Mill on Way Key and forcing most people there to abandon the island. The storm probably came ashore in the Horseshoe Beach area of Dixie County, but once again Cedar Key was on the worst side—the south side—of the storm and bore the brunt of the winds and tides. The damage was so great and the depletion of timber so complete that the companies did not rebuild. Just as the tidal wave was passing, fire broke out in the Bettelini Hotel, one of the more beautiful buildings in Cedar Key, and then spread to the Schlemmer House. It then rushed across to the customshouse, destroying all three buildings. Other ruined buildings included the Methodist Episcopal Church South, the Christian Church, three African American churches, most fish houses and many private residences.

The houses on the higher parts of Atsena Otie Key escaped destruction, but the two mills at the water's edge were demolished. There were some houses moved from Atsena Otie after the 1896 hurricane, including four houses on Second Street where Park Place condominiums are now located, as well as others that have long since been destroyed or torn down. Those still standing include the Eagle's Club building, the Prescott Building (where the *Cedar Key Beacon* newspaper office was later located) and the first portion of the Andrews House (two additions were made in the early 1900s after it was moved to

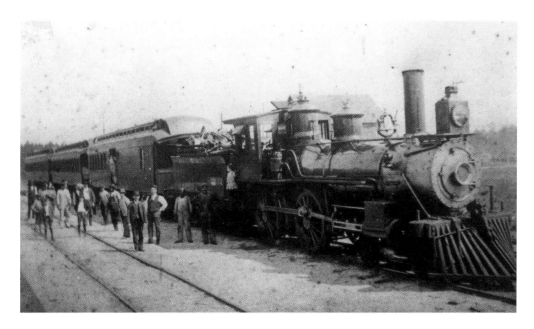

The railroad would serve Cedar Key until 1932. *Image courtesy of Lindon Lindsey.*

Cedar Key). The lumber mills did not rebuild because they had pretty much exhausted the timber in the area and had not done any replanting for the future. Most of the structures on Atsena Otie eventually deteriorated, but the in-ground cistern remained.

Of the one hundred or more sponge boats anchored south of Cedar Key the night before the disaster, twenty sank with all on board. The storm completely washed away four miles of track belonging to the Florida Central & Peninsular Railroad on Way Key. It destroyed over a thousand packages of cedar slats—the area's chief export—along with hundreds of logs still waiting to be processed. It forced boats of all sizes and shapes, including a two-masted schooner, into the streets of Way Key. The thirty-mile-long devastation up the Suwannee Valley ruined so many turpentine stills and stacks of pine that some 2,500 people lost their jobs. With the loss of so much pine, turpentine, cedar and sponges, the importance of Cedar Key as a port declined, and the railroad reduced its schedule to the town.

A dozen or so people were killed on the islands around Cedar Key, and many more suffered severe injuries. More than half the homes in a wide area were destroyed. In the inland area the unpicked crops were ruined, and even the cotton that had been picked and stored was blown away by the storm. About 75 percent of the trees were blown away. Assistance came from as far away as Jacksonville and other places throughout Florida.

The 1896 hurricane did so much damage up the Suwannee River that steamboating was greatly curtailed in the decade after that. Ironically, that was the same year that the last and largest steamboat to run on the river, the *City of Hawkinsville*, was built in Abbeville, Georgia. The 319-ton stern-wheeler served Cedar Key, Old Town, Clays

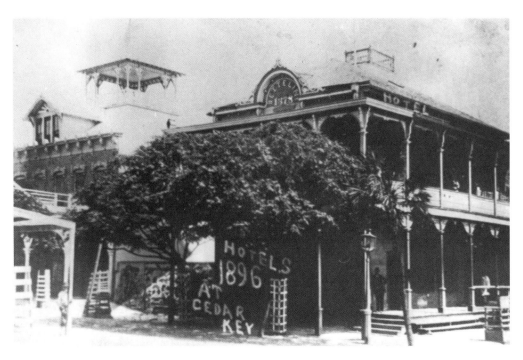

The Bettelini Hotel was a major facility in the 1890s. *Image courtesy of Lindon Lindsey.*

The Eagle Pencil Factory was greatly damaged in the 1896 hurricane. *Image courtesy of Lindon Lindsey.*

Landing and Branford. The vessel stretched 141 feet and had two decks, a single stack, a square stern and a molded bow. One of her jobs may have been to help in the building of the rail bridge at Old Town, a task that hastened the passing of the steamboats in favor of the trains. She served until May 1922, at which time steamboating on the Suwannee ended. She rests in the river near Old Town (minus her top deck, which was removed because it presented an above-water traffic hazard). In 1991, the Florida Department of State dedicated the site near Old Town on the Dixie side of the Suwannee as an underwater shipwreck park to instruct visitors about Suwannee River steamboating through the *City of Hawkinsville*.

The End of the Nineteenth Century

The 1896 hurricane was like an exclamation point to the end of the century, signaling not only how much the area was still subject to the forces of nature, but also how the town had been in decline for the previous decades, ever since Henry Plant had decided to take his railroad south to Tampa. The town's population had peaked in 1885 at a little over two thousand, a figure it would not reach again up to the present time. People began moving away with the lack of jobs. Businesses were struggling, property assessments were falling and higher tax rates seemed probable in order to keep the budget balanced. At the turn of the century, the population had dwindled down to around seven hundred.

1900–1909

ATSENA OTIE

Norene Andrews and Katie Andrews recalled what life was like on the island in the early 1900s. About thirty-five families lived there then, some in two-story houses. The families kept chickens and used fertilizer made from sea grass on the gardens. The gardens produced many vegetables and fruits, including guavas, peaches, pears and plums. A sidewalk led from the dock to the cemetery. The island had a church, which a preacher would visit once a month, and a school, although some of the children went across the channel to Cedar Key for lessons.

OYSTERS AND FISH

In the first decade of the new century, many local people were engaged in the oyster business. Cedar Key had two oyster-canning factories: the Mahoney Company and the Rouge Canning Plant, which alone employed fifty people as tongers and processors. By 1909, the black-point oyster beds had provided a good living for local harvesters, who could ship them off to large restaurants up the east coast like Delmonico's in New York City. However, over-harvesting of the oysters led to a closure of the oyster beds to commercial fishermen for over thirty years. Around 1909, Dr. Daniel Andrews bought the Rouge Canning Plant with the purpose of converting it to the manufacture of palmetto fiber brushes.

Fish continued to provide much of the local income at the end of the nineteenth and beginning of the twentieth centuries. In an article by Denise Trunk, mullet fisherman Charles "Mo" Beckham noted that the town used to have six fish houses on the pier and that fishermen would bring their boats up to the dock, unload the fish barrels and send them on by train to Fulton Fish Market in New York City. Some seventy-five crabbers and fishermen, in addition to other laborers, worked for the Cedar Key Seafood Cannery.

Right: This in-ground cistern is a reminder of the many people who used to live on Atsena Otie. *Image courtesy of Kevin M. McCarthy.*

Below: The sight of crab traps drying around town has been a fixture of the local life, which has been dependent on the sea for generations. *Image courtesy of Kevin M. McCarthy.*

The Mount Pilgrim African Baptist Church has a cornerstone at the south end of the building that is still visible. *Image courtesy of Kevin M. McCarthy.*

CHURCHES

Christ Episcopal Church was ministered to by various pastors, including Reverend F.S. Hyatt (1905–1907) and Reverend Charles Hedrick (d. 1911), but the small congregation was at times without regular services.

In the early 1900s, at least three African American churches existed around where the Lions Club is today: Bethlehem M.E. Church, the African Methodist Episcopal (AME) Church and the Mount Pilgrim Baptist Church, whose cornerstone at the south end of the building notes that the church was founded around 1900. The Sanborn map from around 1890 clearly shows the three near Sixth and F Streets. The Sanborn Map Company, begun by D.A. Sanborn, a surveyor from Massachusetts who worked for an insurance company, produced maps from the 1860s and later. These maps showed the commercial, industrial and residential sections of some twelve thousand cities and towns in the United States, Canada and Mexico. Such maps are very useful for historians researching the makeup of towns throughout these countries.

1910–1919

DR. DANIEL A. ANDREWS SR.

Dr. Daniel A. Andrews Sr. retired from his dental practice in Indianapolis (around 1909) and moved to Cedar Key, where he supervised the company he had invested in, installing modern machinery for the manufacture of different kinds of brooms and brushes. He hired St. Clair Whitman, who remained as head of the wet department until he retired in 1940, to design the equipment of the factory. The Maddox Foundry in Archer made the machinery for the facility.

Andrews patented the Donax-whisk (1912), using the Latin word *donax*, which meant "reed," "cane" or "a thing of beauty" and was the generic name for the cochina shell. He used palmetto fiber, which was superior to broom corn, and came up with several inventions of special types of brushes for hats, tables, cars and other items. The Standard Manufacturing Company, known locally as the Fiber Factory, employed over one hundred workers—men and women, black and white—making brooms and brushes from palm fiber.

The factory played a major role in the economy of Cedar Key for four decades. According to Dr. Andrews (see the work by Peter Burtchaell in "Further Reading" at the end of the book), for over thirty years the Fiber Factory averaged 107 workers at the plant and twenty in the woods gathering the material for the factory. Only during World War II, when most workers went to wartime jobs or service in the military, did the plant have its fewest number of workers: twenty-nine. During the Depression, Dr. Andrews paid wages of 15¢ to 65¢ an hour, fees which rose to between 45¢ and $1.25 an hour during World War II, the amount depending on the skill required in each job. All of the workers were local, and the demand for the product was so steady that they were able to work even during times of economic downturns.

The cabbage palms from which the fiber and brushes were made were called "buds," probably because only the small trees were used. When the palm is small, it is composed of "boots," which—after the tree is cooked—can be individually separated, similar to a stalk of celery. The entire tree was used in the process, but the trees were a

renewable resource because the palms reseed themselves and grow so rapidly that the same territory could be used every three to four years. The workers used an average of between two thousand and three thousand trees per month; there was never a shortage of the trees. However, cheap synthetic fibers, along with the 1950 hurricane, ended this industry in Cedar Key.

The Andrews House was originally a three-room mill house on Atsena Otie. After the 1896 hurricane, workers moved the house by barge to the Fenimore Mill Point. They later added two sections to it. The Standard Manufacturing Company, which Dr. Daniel Andrews Sr. built, was on the eastern tip of the island. In the heyday of the Standard Manufacturing Company, the United States had only two other fiber factories: one in Jacksonville and one in Sanford, Florida.

The office of the company occupied the large front room on the first floor and over the years also served as the office for the first power and light company, the Western Union, and the Island City Investment Company. Dr. Andrews never ran a professional dental practice in Cedar Key but on Sunday afternoons did dental work on family members and a few friends. He would pull teeth at no charge for anyone with a severe toothache. The Standard Manufacturing Company operated from 1910 until 1952 except during World War II, when it closed for a lack of workers.

Dr. Andrews became vice president of the Cedar Key State Bank (1916–1923), served as mayor of the town three times, was on the board of Levy County commissioners, was the first president of the Cedar Keys Board of Trade and served as secretary of the chamber of commerce, which was established in 1922.

Dr. Andrews had married Margarette Rozelle in Indiana, but she died six months later of leukemia. They had no children. He married a Cedar Key native, Cora Tooke, in 1917, and they had a daughter, Helen Marjorie (who died of pneumonia in 1922 at age four), and two sons: Dan Jr. (an accountant who died in Ocala in 2003) and John William (a retired physician in Gainesville who now lives with his wife, Lucille, in Cedar Key in the restored Tooke home). Dr. Dan Andrews Sr. added a second story to the house that became known as the Andrews House at 39 Second Street. They built another addition when their family began to grow in the 1920s. The back stairs were once on the outside of the house, as was common in houses at the time. When those stairs were later enclosed, one window was kept on the interior wall of the stairway, a strange feature for those who did not know where the stairs had originally been.

Dr. Andrews died in 1960 at the age of eighty-three. Mrs. Cora Andrews remained in the house until the age of ninety, when she moved to Gainesville to live with her son and his wife until she died at the age of ninety-eight.

BUILDINGS

In Cedar Key in 1910, W.R. Hodges Sr. built a house, which is today the best local example of Queen Ann Victorian architecture. He used heavy timbers brought over from Atsena Otie after the Faber Mill was dismantled. The building on Second Street,

The portrait of Mr. St. Clair Whitman hangs on the wall of his restored home near the state museum. *Image courtesy of Kevin M. McCarthy.*

which has not changed much over the years, was apparently modeled after one on Chambers Island built by Captain John L. Inglis. Randolph Hodges also lived in this house in Cedar Key. The senior Hodges moved several houses from Atsena Otie, put them in the dock area and named the project Hodgetown.

In 1914, Langdon Parsons, son of one of the original owners (John Parsons), sold the Parsons and Hale building. Simon Feinberg, a businessman in North Florida, bought the building in 1915 and converted the general store into the Bay Hotel. Between 1915 and 1920, he built much of the interior, including the stairway, and added a second-floor balcony and wraparound porch at the south and west sides of the hotel. Mr. and Mrs. W.L. Markham, who moved from the White House Hotel, managed the Bay Hotel until 1918.

After the 1896 hurricane, W.R. Hodges moved the Prescott Building from Atsena Otie Key to a location on Second Street, where the post office is now located. In 1918, he moved it across the street, and the front of the building became the back, and the back became the front. The *Cedar Key Beacon* newspaper office is in it now.

Feinberg died at the hotel in 1919 under somewhat mysterious circumstances. He had gone to Cedar Key to collect the rent from his manager and apparently discovered that the manager was operating a whiskey still in the attic during those days of Prohibition. The manager had hidden the copper pipe from the still in the annex roof behind a false

roof about twelve inches below the proper roof. In any case, after a huge meal, Feinberg retired for the night but never woke up.

The Masonic Hall on the southeast corner of Second and D Streets also traces its beginnings to 1910, when it replaced an earlier building. The first floor was used for the H.B. Rogers and Boaz Wadley Store, later for the Fowler-Wood Land Co., a barbershop, grocery store and, most recently, a real estate office and a bookstore. You can still see the Masonic lodge stone on the ground level at the entrance to the bookstore.

CHURCHES

Christ Episcopal Church, which had been served by various pastors, had Reverend W.R. Creasy (1913–1915) and Reverend A.O. Worthing (1915–1917). A 1916 fire totally destroyed several buildings in town, including the church and rectory, but the church furniture was saved. Parishioners then attended services in a vacant store belonging to the church treasurer, J.B. Lutterloh. Reverend Fryer was rector of the church for a short time (1917–1918), after which services were irregular.

BANK

In 1912, local citizens Dr. Dan Andrews, W. Randolph Hodges and Dr. James Turner organized the Cedar Key State Bank and built a brick building on the northwest corner of the intersection of Second (Main) and C Streets. No doubt the economic success of Dr. Andrews's Fiber Factory and the income it brought in to him and the local community led to the establishment of that bank. Before then, local people had to rely on banks in Jacksonville and Gainesville or deposit their money, especially large sums, with the C.B. Rogers Company in Cedar Key. The officers of the bank were local people: W. Randolph Hodges, president; A.P. Schlemmer, vice president; W.H. Anderson Jr., cashier. Within five years, the bank, which began with a capitalization of $15,000, had assets of over $51,000. It served as the town's only bank for many decades and is today the only neoclassical structure in the downtown area. The entrance, which used to open onto Second Street, was changed to face C Street.

CEDAR KEYS LIGHTHOUSE

In 1915, federal officials extinguished the light in the lighthouse on Seahorse Key, deeming it no longer necessary for the shipping traffic. The island would later become part of a national wildlife refuge, which helped protect the hundreds of brown pelicans that live in the area, possibly the largest rookery in the country for such birds. Often—for example from March 1 through June 30—the U.S. Fish and Wildlife Service closes Seahorse Key and a three-hundred-foot buffer around the island in order to allow the

Above: The former Masonic lodge has become a real estate office and a bookstore. *Image courtesy of Kevin M. McCarthy.*

Right: The bank building is one of the longest surviving brick buildings in town. *Image courtesy of Kevin M. McCarthy.*

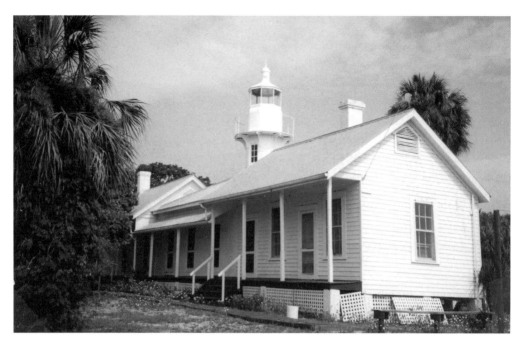

The Cedar Keys Lighthouse, though no longer functioning as a light beacon, would become part of a marine biology laboratory. *Image courtesy of Lindon Lindsey.*

large nesting colony of birds there to nest in peace and quiet, away from humans. The University of Florida now uses the island for marine biology research.

School

Cedar Key High School was built in 1915 and dedicated in 1916. Fire destroyed the building in 1943.

The principals of the school in that first decade of the school were W. Frank Osteen (1915–1917, at which time he became superintendent), John Hill (1917–1918) and Sidney D. Padgett (1918–1922).

Local Industries

By 1910, many local fishermen were using fishing boats powered by gasoline engines, which enabled them to reach farther points and to return to the dock much more quickly than by sailboats. The demand for gasoline led to the establishment of the Standard Oil Dock Station and Marina, which facilitated the filling of the boat engines at the dock. In 1910, the first year of its use, fishermen bought and used twelve thousand gallons, a respectable amount that would grow over the years.

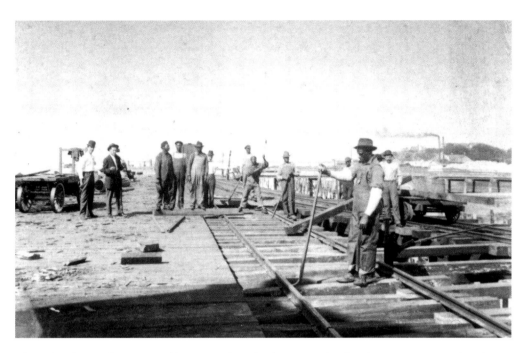

The railroad to Cedar Key would require a lot of upkeep over the decades. *Image courtesy of Lindon Lindsey.*

Because the fishermen depended on the railroad to take their fish to markets elsewhere, there were seven fish houses built along the train trestle to facilitate the loading of fish directly from the fish houses into the railroad cars. At the peak of the fishing industry, the town had about one hundred full-time fishermen fishing mainly for mullet and redfish. One effective means of fishing was to place a net, measuring about 250 feet across, from Seahorse Key and connected to pilings. The net, called a "pound net," was composed of a "lead" of pilings supporting a net, which formed a barrier, leading the fish into an impoundment about thirty feet across with a net underneath that could be raised to remove the fish. The net could produce a single catch of several thousand pounds of fish.

The Standard Manufacturing Company did well in that decade as more and more people wanted its products. Even during World War I, when many men went off to serve in the military, women and high school children took their place at the Fiber Factory. A small field crew of whites and African Americans did the hard work of cutting the cabbage buds for the factory.

Railroad

The train took passengers and commerce to and from the east coast of Florida. There were typically two trains each way per day, but their timings varied considerably over

The *Island City News* did not last very long. *Image courtesy of Lindon Lindsey.*

the years. The fast passenger train generally departed in the early morning, between 5:30 and 7:00 a.m., depending on the particular year, and returned in the evening, at various times between 4:00 and 9:00 p.m. The run to or from Fernandina took between $8\frac{1}{2}$ and 9 hours in the 1880s, but had come down to between $5\frac{1}{2}$ and 6 hours in the 1920s. Meeting the trains at the depot was a highlight for many, including those waiting for the mail.

The train helped bring in many supplies of the local companies in Cedar Key. For example, it brought in enough different kinds of good lumber for the boat builders to have a good business there.

1920–1929

National Leprosarium

In 1921, Congressman Frank Clark told local official W.R. Hodges that authorities had chosen Cedar Key as the site of a leper colony, a national leprosarium. W.R. Hodges and his brother, T.R. Hodges, began a media campaign and official visits to Washington to stop the plan. When the surgeon general admitted that mosquitoes could carry the disease from North Key or Snake Key, where the facility was to be located, three miles to Way Key, where Cedar Key was, and infect persons there, local officials were outraged and managed to have the facility established elsewhere—in Carrville, Louisiana.

Rosewood

A racial incident in Rosewood, ten miles east of Cedar Key, probably had an effect on the lives of the African Americans in the coastal town. On January 1, 1923, a white woman in nearby Sumner claimed that a black man had attacked her, a charge that led to the formation of a white vigilante mob that searched for blacks and killed at least six of them. African Americans continued to live and work in Cedar Key until the Fiber Factory closed in 1952.

School

The 1924 class of five seniors was the first to graduate from Cedar Key High School (CKHS). Elsie Day, the only girl among the seniors, married another senior, Wallace Brush.

The 1925 class had the first commencement exercise in the newly accredited high school on the island. That distinction meant so much that one member of the Class of

1924, Wallace Brush, returned in 1925 to walk down the aisle with the first accredited group of graduates in Cedar Key.

The 1925–1926 faculty, under the guidance of Principal A.J.G. Wells, consisted of Mr. H.E. Atkinson of Holly Springs, North Carolina (science and mathematics) and Ms. Lucille Carrol Moseley of Whitesville, Kentucky (history and English).

The principals of the school that decade were Sidney D. Padgett (1918–1922), M.G. Donaldson (1922–1923), Mr. Fletcher (1923–1924), Major Merrit Johnson Nash (1924–1925), A.J.G. Wells (1925–1926) and Sidney D. Padgett (1926–1931).

The name of the annual yearbook, published by the junior class, was the *Pelican*. Now the yearbook is called the *Shark*, after the mascot of the school.

CHURCHES

In 1920, Reverend A.E. Dunaham became rector of Christ Episcopal Church, although he was also in charge of St. Mark's in Starke. In 1925, work began on a new church building on the same site as the one burned down in 1916. The Right Reverend Frank A. Juhan baptized several in the new building in 1925. The following year, the Reverend Russell S. Carleton was assigned to Christ Episcopal Church in Cedar Key and St. Mark's in Starke. Work continued on completing the interior of the church.

The congregation of Cedar Key First Baptist Church bought lots on Second Street in 1922–1923 for a new church building. Church members Henry Taylor and Joseph Wilson built the pews and lectern. The pastor was Reverend Forester Jones.

The congregation of the Church of God (sometimes called the Church of Jesus Christ) built a structure in 1925 at 709 Fifth Street, and it served the community as a Pentecostal church up until the 1970s, when it was sold to a builder of small fishing boats. It later became Wells Wood Furniture, a facility for building wooden furniture. In 2007, the Cedar Key City Commission placed the building on the local register of historic places.

BUSINESSES

In 1923, Vaughn Hardee expanded the Chiefland Ford dealership to Cedar Key. Hardee did well, selling a Model T almost every other week. He joined with W.J. Tate and Fred Davidson to sell cars from the corner of Second and B Streets, a business that continued to 1926, when the Cummer Cypress Mill at Sumner burned down, which forced workers to go elsewhere for work and ended the car-selling business in Cedar Key. The Model-T Ford Roadsters sold for about four hundred dollars, but a sedan with shock absorbers, windshield wipers, a large steering wheel and other extras would cost about eight hundred dollars. A train would deliver the unassembled cars and then a crew would put them together. It would not be until the late 1990s that another car dealership would sell cars in Cedar Key.

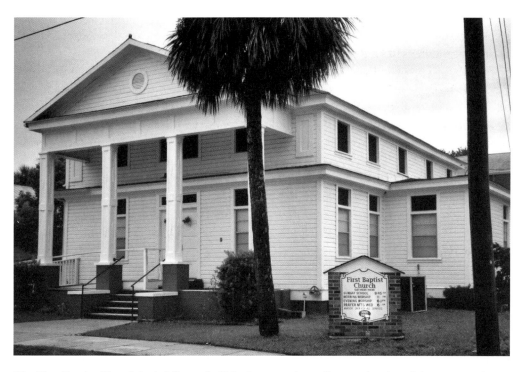

The First Baptist Church had different facilities in town, depending on the size of the congregation. *Image courtesy of Kevin M. McCarthy.*

Around 1923, Dr. Daniel Andrews Sr. bought most of Atsena Otie Key from the Faber Company for five hundred dollars. In 1925, workers tore down the Cedar Key Sponge Exchange. According to Ruth Verrill, the town had a new cigar factory open in 1927. The factory had ten benches and six cigar workers. The men in charge were R.B. Owens, owner and manager; R.A. Thomas, foreman; and J.M. Croft, sales manager.

INFRASTRUCTURE AND ROADS

The city got electricity and water in the 1920s. When the Cedar Key Light and Power Company, built by Dr. Andrews and located near the Standard Manufacturing Company, purchased a 120-horsepower diesel engine and generator, fifty-five local people paid a $9.00 meter deposit, and workers wired sixty-three houses for electricity. W.H. Hale, who had a local real estate and hardware business, installed the meters in eight of his housing units. Only two of the fifty-five subscribers were African Americans. The rates were reasonable. Private dwellings and churches paid a minimum of $1.50 per month.

In 1924, state officials had a paved road built from Archer to Cedar Key. Not only did that facilitate more people going to the coastal town, but local businesses also prospered. For example, the Standard Oil Company agent in Cedar Key sold fifty thousand gallons of fuel a month to the contractors building the road. The Cedar Key Hotel was full most

Left: Greeks, often from Tarpon Springs, would gather sponges in the Gulf of Mexico using the hard-hat method, which allowed them to go very deep in the water. *Image courtesy of Florida State Archives.*

Below: The telephone exchange was in the Boaz Wadley House. *Image courtesy of Kevin M. McCarthy.*

of the time during construction, and even local homeowners took in boarders who were working on the road. The construction of the road also increased land values in Cedar Key, a phenomenon that would occur with increasing frequency as more and more outsiders discovered the pleasures of living in the town.

Cedar Key got its first telephone exchange in the 1920s, when workers installed the facility in the Boaz Wadley House on Second (Main) Street. Mary Seymoure operated the telephone facility, but then Florence Hughes (the wife of Harry Hughes) operated it. In an article entitled "History of the Telephone Service in Cedar Key" in P.H. Day's *Destination Cedar Key*, Elizabeth Hughes Griffis described how her mother, Florence Hughes, who was working for Southern Bell in Gainesville in 1929, took the position in Cedar Key because it allowed her to stay with the company but not have to hire babysitters for her two daughters. Elizabeth's father, Harry Hughes, was a musician with a small orchestra who could move to the coastal town with his family.

The telephone service at that time had eight subscribers. Mrs. Hughes had to be responsible for the service twenty-four hours a day, seven days a week. The whole Hughes family became skilled at operating the switchboard, which was in their living room. If a person without telephone service received a call, the Hughes operator would notify the closest neighbor with telephone service, and that person would go to the office to receive the call. Florence Hughes wrote:

> *We had two lines to Gainesville, and if someone wanted a number there, we would ring the Gainesville operator and ask for the number, then we would connect our caller, keep track of the time of the call and collect the money for the call. If the call was beyond Gainesville, we would give the information to the Gainesville operator. When she reached the party being called, she would ring us back and then she kept track of the time and the charges and let us know how much to collect.*

The telephone facility also had a party line to Otter Creek and Gulf Hammock. The operator reached the correct number by the number of rings when she cranked the machine. Local people in Cedar Key who wanted to make a call—and they seemed to do so at all hours of the day—would tell the operator whom they wanted to call and then sit on the porch swing, waiting for the call to go through. A payphone there provided some privacy to the caller as well as the ability for people to call late at night. It could become particularly noisy when Greek spongers from Tarpon Springs—who were in town to buy supplies, refuel their boats or simply get out of bad weather—would descend on the Wadley House to make calls back to their families in Tarpon Springs.

Later, when the federal government passed the Wage and Hour Law, Mrs. Hughes could no longer work the long hours she had been used to and had to hire more operators. Because the Child Labor Law had not been passed yet, Mrs. Hughes signed up her daughter, Elizabeth, as a night operator. Her younger sister went on to work for the telephone company, which became BellSouth.

Mr. St. Clair Whitman liked to drive his 1926 Chevrolet Touring Car around town. *Image courtesy of Lindon Lindsey.*

The dining room of the Island Hotel could be made into a dance hall. *Image courtesy of Kevin M. McCarthy.*

HURRICANES

On September 30, 1920, a category one hurricane weakened to a tropical storm and made landfall between Levy and Dixie counties. Fortunately, it had weakened from hurricane-strength before hitting land and so did not cause too much damage.

CEDAR KEYS NATIONAL WILDLIFE REFUGE

President Herbert Hoover signed Executive Order 5158, dated July 16, 1929, and established the Cedar Keys National Wildlife Refuge, a colonial (nesting rookery) bird sanctuary. The refuge included Bird, North and Snake Keys. President Franklin Roosevelt's executive order, dated November 6, 1936, would later add Seahorse Key to the refuge.

PEOPLE

Mr. St. Clair Whitman had a 1926 Chevrolet Tourin, of which he was very proud. However, the children of the town were told to get out of the way when he was out driving. Whitman, who bought his wood-frame house at Goose Cove in 1920, made it into a museum to showcase the many local artifacts he collected over the years. His descendants donated the house to the state museum in Cedar Key. Visitors there can see what life was like in the town in the 1920s and 1930s.

1930-1939

THE END OF THE RAILROAD

In 1932, railroad officials abandoned the line from Archer to Cedar Key, thus marking the end of Florida's first cross-state rail line and worsening the financial condition of Cedar Key. The closure of the railroad to Cedar Key affected most of the industries there, including the fishermen who had depended on trains taking their fish to markets elsewhere. Some people, however, adapted to the new situation, using old trucks to transport turpentine from Cedar Key to the port in Jacksonville, a trip that the railroad would have taken before it closed down. Others would ice down fish in boxes and then take them by truck to as far away as New York City, a trip that took thirty-six hours with stops along the way for the replenishing of ice.

In the early 1930s, Florida Motor Lines, later absorbed by Southeastern Greyhound Lines, began operating a bus service between Cedar Key and Gainesville twice a day.

HURRICANES AND STORMS

Two bad storms hit during the decade. On July 23, 1934, a tropical storm hit below Cedar Key near Yankeetown with winds of forty-six miles per hour.

On September 3, 1935, a category five hurricane with maximum sustained winds of 161 miles per hour hit the Florida Keys and killed some four hundred military veterans working on Flagler's railroad to Key West. The storm then went into the Gulf of Mexico, headed north and passed within thirty to forty miles of Cedar Key as a category one storm. It destroyed the Maddox Theater at Second and C Streets in Cedar Key; the doors from the theater are displayed in the Cedar Key Historical Museum. The houses along the beach were damaged in that storm, and personal property was spread all over the beach.

When the railroad stopped running into Cedar Key, people could take the bus to Gainesville. *Image courtesy of Lindon Lindsey.*

THE BIG DOCK

When the railroad stopped running to Cedar Key in 1932, county officials agreed to buy the right-of-way for docks from the railroad company. In 1935, when part of the wooden dock burned down, the federal government made funds available for reconstruction. It did ask the local community for $8,000 to help defray the expenses, at which point Dr. J.W. Turner and others donated $500 toward the project, and local officials asked the county to contribute $1,500 and trucks, which the county agreed to do. It would take several years for Work Projects Administration (WPA) workers to rebuild the dock, but the construction provided much-needed jobs for local workers.

AIRSTRIP

Cedar Key Properties Inc. gave land to the state in 1936 for an airstrip, and several years later the federal government built an emergency landing strip there. What would become the George T. Lewis Airport, named after a longtime area resident in 1947, would eventually be 2,357 feet long and one hundred feet wide about a half-mile southwest of the town and on county-owned land. The airstrip runs from northwest to southeast. The state agency that preceded the Department of Transportation established the airstrip in 1939. The timing was appropriate, since it was used during and after World War II as an air and sea rescue base.

The airstrip would be the scene of many accidents as pilots unfamiliar with the area sometimes landed in the Gulf. *Image courtesy of Kevin M. McCarthy.*

PEOPLE

Dan McQueen, an important local African American, was a former slave who became a riverboat captain and lived in Cedar Key until he died. He began by washing dishes in a steamboat, studied the river thoroughly and worked his way up to become one of the most skilled pilots on the Suwannee River, knowing the river so well that he could deliver logs to Cedar Key in the dark. He is buried in an old cemetery in Old Town near Fanning Springs.

One of the leading doctors of Cedar Key in the 1930s was Dr. James Wilcox Turner (1878–1940). After being born in Wilcox County, Georgia, the young boy was taken by his family to Levy County, where he was educated in the public schools. He graduated from Stetson University (1899) and Tulane Medical College in New Orleans (1904), worked in Louisiana and then in Bronson and Otter Creek, Florida (1905), before moving to Cedar Key (1911). During World War I, he was the examining physician for the local draft exemption board, then assistant state health officer (1910–1938), while also serving as surgeon for Seaboard Air Line Railway (1912–1932). He helped organize the Cedar Key State Bank (1912) and served as its president (from 1913 to around 1938). He also had a large farm and raised animals. He was elected to the State Senate (1917) and re-elected many times. He served as president pro tempore of the Senate (1931), becoming well known for sponsoring education, road and highway laws; he helped

introduce a bill to establish the state library in Tallahassee, now located in that city's R.A. Grey Building. He was a trustee of the Cedar Key schools for many years, served as chairman of the board (1914–1933) and was a well-thought-of man in the town.

The principals of Cedar Key High School that decade were Sidney D. Padgett (1926–1931), A.J.G. Wells (1931–1936), M.F. Keister (1936–1938) and C.C. Matheny (1938–1940).

CRIME

In November 1932, three Greek spongers from Tarpon Springs (George Georgio, Stathis Johanaunou [or Johannon] and Theodore Smarkos) were arrested by Justice of the Peace T.W. Brewer and Constable Thomas Booth for public drunkenness and put in jail. On November 28, while the men were in jail, the building mysteriously burned to the ground, killing the men inside. After examining the corpses, Dr. J.W. Turner concluded that the men's skulls had been crushed, probably before the fire was started, to cover up the deed. Brewer and Booth were convicted of the crime and sentenced to life terms. Afterward, the Greek sponge boats stopped coming into Cedar Key. Carol Keith's *A Watch for Evil* is a novel about the event.

BUILDINGS AND ROADS

The Bay Hotel had different owners during that and the following decade. Owners included J.B. and Pauline Witt and later George T. Lewis (for whom the Cedar Key airport is officially named). The hotel had different names, including the Cedar Key Hotel and Fowlers Wood or Fowlerwood, when a Mr. Fowler owned it. A Mr. Crittenden managed the hotel during the 1930s and he may have used it as a whorehouse during that time.

During the Depression, the hotel suffered, as did all the businesses in Cedar Key. The bank, which had to close in 1932, but reopened the next year, foreclosed on one owner, and another owner may have tried to burn it down. In fact, fires almost destroyed the building several times. One week saw three fires there, but volunteers from the fire department, which was just across the street, managed to put out the flames before much damage was done. Mr. Ray Andrews acquired the hotel in the late 1930s and, along with his brother (Forest Andrews) and sister-in-law (Nettie Andrews), ran it through the war years.

The Works Progress Administration (later the Works Projects Administration— abbreviated WPA) that President Franklin Roosevelt created in 1935, and which Congress funded as part of the New Deal, put many out-of-work laborers to work, including in Cedar Key. There in the 1930s and 1940s they paved many of the streets of the town. Before then, the only street in town that had any kind of paving was Second (Main) Street.

The Church of Christ has been a strong member of the community for decades. *Image courtesy of Kevin M. McCarthy.*

Churches

Around 1930, evangelists for what would become the Cedar Key Church of Christ began visiting the town and having tent revivals on the open lot next to the old Suwannee Hotel near the later Park Place Motel. The two-week-long revivals had much strong preaching and singing of old-time gospel songs. Often two preachers, who stayed with local families, would participate. The first evangelist was C.D. Moore. When the local people wanted services more than the twice-a-year revivals, they rented space in what became the L&M Bar. The first full-time minister, R.C. Crawford, lived above the church.

PEOPLE

The census reported that Cedar Key had a population of 988 in 1940: 892 whites and 96 blacks. According to researcher Peter Burtchaell, the decline in the number of blacks from 179 in 1930 to 96 in 1940 was due to the fact that during hard times, for example the Depression, blacks tended to return home to Cedar Key, where they could make a living and provide for their families through fishing and crabbing, whereas when the economy became stronger elsewhere, for example the war years of the 1940s, they went away for better-paying jobs.

THE BIG DOCK

After the Big Dock was finished, the federal government, which was already using part of the dock for geodetic survey purposes, leased a portion of the facility for $2,500 a month to dock Coast Guard vessels. The Coast Guard took over the City Hall, which became their base. Then the U.S. Army came in and established their headquarters across the street. The U.S. Army had radio-controlled boats that would pull targets for the planes to shoot at. Patrol boats out of Yankeetown and St. Marks would dock at Cedar Key from time to time. The troops had bombing ranges north and south of the city, although occasionally the planes would bomb oyster bars. Both military groups performed rescue missions for pilots lost over the Gulf of Mexico and also searched for German U-boats.

WORLD WAR II

The first men called up in the selective service from Levy County were both from Cedar Key: Warren W. Bishop and Robert A. Boothby. When they left for duty at Camp

Blanding in December 1940, the Boy Scout troop from Bronson saw them off. Some of the local men who did not serve in the military went to Jacksonville to work in the shipyard there.

Cedar Key did more than its share of sending men and women to serve in World War II. One hundred and fifty-two of the local citizens served in that war, a figure that meant that some 80 percent of the eligible residents from the town served in the war, compared with 60 percent nationwide. In 1994, officials put up a monument outside City Hall on Second Street to all the locals who served in that war, the Korean Conflict and the Vietnam War.

The establishment of a Coast Guard Station at Cedar Key, manned by a troop of seventy-five to one hundred men, and of a U.S. Army Air Sea Rescue Squadron, with a troop of fifty men, helped the local economy immensely since the men were paid in cash, much of which they spent in local establishments. Some local women, for example future mayor Helen Johannesen, married servicemen stationed in the town.

The Island Hotel served as the barracks for the servicemen, and what became the Pelican Realty in the former Country Store building was a bar with pool tables and a dance floor. The only transportation in and out of Cedar Key was a bus that ran twice a week between the town and St. Augustine; it would come in on Tuesday, head back on Wednesday, return on Friday and head out again on Saturday.

During World War II, the Western Union office housed in the Andrews House at 39 Second Street in Cedar Key was the recipient of the telegrams telling families that they had lost family members in the war. That same house was headquarters for the Island City Investment Co., which was established to raise money to redeem delinquent city bonds from the Great Depression, which began in 1929.

In 1948, the local chapter of the Veterans of Foreign Wars was organized.

AIRPORT

During and after World War II, pilots used the airstrip, which had been given to the state in 1936, as an air and sea rescue base. During the early days of the airstrip, which workers paved in the 1950s, people began building houses around the area. In 1940, the state transferred the airstrip to the city of Cedar Key. The largest plane to use the airstrip, a B-17, landed during the war when it developed engine trouble and had to make an emergency landing. When mechanics had the necessary parts shipped in and made the repairs, the pilot took the plane to the very beginning of the airstrip, revved up the engine, lumbered down the runway and lifted off into the sky without a lot of room to spare—to the applause and cheers of much of the community, which had gathered to see the spectacle of the giant plane.

The navy out of Jacksonville was training pilots, who would occasionally land at the Cedar Key airstrip. Some of the young pilots would crash when they failed to navigate the short runway. When a crash occurred, George T. Lewis, who lived nearby, would rush to the crashed or overturned plane, help the pilots to safety and then siphon off the

Above: The U.S. Army built a barracks in the middle of town, a building that still exists. *Image courtesy of Lindon Lindsey.*

Right: The U.S. Army docked its boats around Cedar Key. *Image courtesy of Lindon Lindsey.*

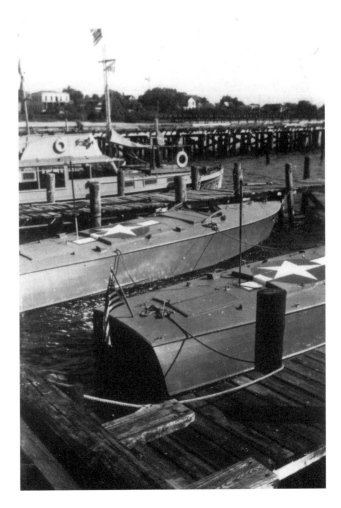

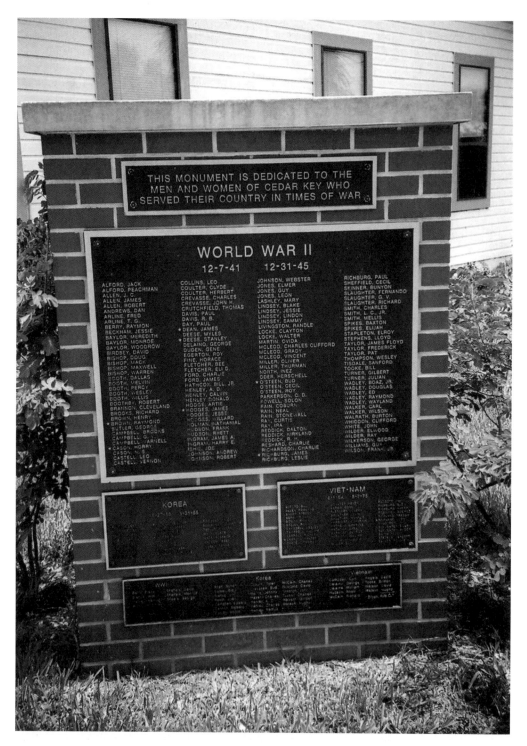

A memorial near City Hall lists the names of all the local residents who served in different wars, including World War II. *Image courtesy of Kevin M. McCarthy.*

gas into a large, fifty-five-gallon tank. He did not want the gas to be wasted. Gas at that time was rationed and in short supply. Mr. Lewis often cooked the pilots big dinners and made them feel at home.

County commissioners decided to use the paved strip at the airstrip as County Road 470, which meant that they would not have to pave an additional two thousand feet of roadway because the pavement was already there. In 1947, officials named the airstrip the George T. Lewis Airport after the area resident.

BUILDINGS

In the 1940s, the main hotel in town had deteriorated markedly. After Bessie and Loyal "Gibby" Gibbs arrived in Cedar Key in 1946, they acquired—along with partner Howard L. Dayton—the building and set about to refurbish it, scrubbing it from top to bottom, renaming it the Island Hotel, and setting a high standard that they would maintain for the next twenty-seven years. Bessie and Gibby eventually bought out their partner, Howard Dayton. Gibby, the bartender, made the hotel bar into a popular gathering place for locals and visitors. In 1948, the Gibbses arranged with artist Helen Tooker to paint scenes on the wall of the bar in return for room and board. She painted murals of Cedar Key and King Neptune, for whom the bar is named.

The owners of the Island Hotel claimed that it had the only bar in Levy County without a television. The cook, Catherine "Big Buster" Johnson, made dining there a great experience. She and Bessie became well known for such delicacies as Key lime pie and a heart-of-palm salad, the latter of which had a combination of mayonnaise, vanilla ice cream and peanut butter.

Over the next few decades, magazines and newspapers with large circulations—for example the *Chicago Tribune, Colliers, Coronet, National Geographic Magazine* and the *New York Times*—often did articles about the hotel and the town, probably because writers thought both were "charming," "unusual" or "quaint." In any case, such publicity attracted more and more visitors and money.

AFRICAN AMERICANS IN CEDAR KEY

Catherine "Big Buster" Johnson, the African American cook at the Island Hotel, and other African Americans lived in a part of town called the Hill, which was to the northwest of the downtown area. Catherine's husband, Ivory Johnson and his friend, Ervin Blackshear, used to fish and oyster together and would supply a plentiful catch to the hotels downtown. African Americans had their own churches, but very little of their presence from those days is still there. They had their own grocery stores, Masonic lodge, restaurant and school. The separation of the races is even evident in the local cemetery, where blacks are buried.

The owners of the Island Hotel claimed that their King Neptune Bar was the only one in the whole county. *Image courtesy of Kevin M. McCarthy.*

Mr. St. Clair Whitman's house was moved to the state museum and restored for visitors to see what a typical Cedar Key house used to look like. *Image courtesy of Kevin M. McCarthy.*

CHURCHES

In 1945, the congregation of the Cedar Key Church of Christ bought property on the corner of Third and E Streets and built their present building there. In constructing the church building, workers used material brought over from the old Red Bug Church of Christ, which had stopped meeting.

In 1940, Mr. J.B. Hunt went to Christ Episcopal Church to assist with services and the young people's organizations. By 1941, when Reverend Yerkes's area became too large for one priest to serve, the bishop sent the Reverend Cornelius Tarplee to work in the southern half, which included Christ Church. When Mr. Tarplee was reassigned elsewhere in 1942, Reverend Yerkes assumed the responsibilities for Cedar Key. The congregation sold a house deeded to them by the late Jennie Hayden and bought a house right behind the church. The Andrews family gave lights for the church building in honor of Dr. and Mrs. George Andrews.

In 1946, the Cedar Key First Baptist Church bought a dwelling and moved it to the church site for the pastor's home.

CEDAR KEY HIGH SCHOOL

Cedar Key High School, built in 1915 and dedicated in 1916, was destroyed by fire on December 19, 1943, during the Christmas holidays. Coast Guardsmen and local firefighters rushed to the scene, but a strong wind quickly spread the fire and destroyed the building that housed student records, as well as an auditorium where plays and movies were put on. Many of the school records were burned, which made compiling a list of graduates—for reunions, for example—very difficult.

The principals of the school that decade were C.C. Matheny (1938–1940), S.B. Groom (1940–1942), Joe Strickland (1942–1945) and Sidney D. Padgett (1945–1962).

The school had its smallest graduating class in 1945 with one graduate: Nolan Cannon.

FIRST MUSEUM IN TOWN

In 1945, St. Clair Whitman established the town's first museum in what had been the bedroom off the front porch of his family's home, which he enlarged over the years, adding a wing to one side. There he displayed some of the many artifacts he had been collecting since he had moved to Cedar Key in 1880, when he was twelve years old. When motel owners downtown called him, he would invite over four guests at a time, sit them around a table and bring out his artifacts, including arrowheads, alligator skulls and shells. The original house, before being moved to the site of the Cedar Key State Museum, was at the western end of Sixth Street on Goose Cove on the site of a Native American midden.

MARINE RESEARCH

In 1947 and 1948, the University of Miami Marine Laboratory conducted research along Florida's west coast to find out why sponges were dying there. Meanwhile, a citizen of Cedar Key, Elias Roland, wrote a letter to officials in Tallahassee complaining about the lack of available mullet in the gulf and the declining quality of local lobsters. Two researchers from the University of Miami, Robert M. Ingle and Jack Sutton, went to Cedar Key to conduct the research into the problems of the mullet and lobster. (In the 1990s, researchers found that the mullet population declined during the mullet-spawning season when the fish were caught for their eggs rather than their meat.)

After they conducted their initial research and made their reports back in Miami, Jack Sutton returned to Cedar Key to continue his research into the mullet problem, helped by such fishermen as R.B. Davis, who owned one of several fish houses along the old dock, the one that used to carry railroad tracks. After accumulating much data over eighteen months—data about the spawning times and places of mullet, their growth rate, habitats of the young, and information about the temperature, salinity and dissolved substances—Sutton was ready to write his thesis. However, a huge fire swept through the buildings of the outer dock, including R.B. Davis's fish house, and destroyed many of the facilities, as well as Sutton's notes. Sutton abandoned his plans for an advanced degree in biology, built a tropical-fish hatchery nine miles east of town, worked in a local bank and operated a crab production plant run by seafood entrepreneur Ted Rienke from Maryland, before eventually leaving the area for other opportunities.

CRIME

In the well-done ongoing series of the history of the county, *Search For Yesterday*, Sheriff G.T. Robbins recalled several incidents involving Cedar Key. In 1946, two young men broke into a service station in Cedar Key and stole a car, loaded with mechanic's tools, which belonged to a Greek mechanic from Tarpon Springs who was in Cedar Key to work on the engine of a sponge boat. The young men drove all the way to Texas, where a sheriff there caught them and, within one hour of contacting Sheriff Robbins in Levy County, had the extradition papers signed. The Levy County sheriff and an attorney drove two days out to Texas, picked up the fugitives, drove two days back and had the men stand trial. Each was sentenced to five years, although one of them, Hobo Joe, made parole and the other one, Charlie Rae, did not.

In 1947, two men from Macclenny broke into the Cedar Key State Bank and tried to cut a hole in the vault door. When a Mrs. Day, who lived upstairs across the street, saw the sparks from the cutting torch, she called a friend, George Delaino, who contacted Police Chief Warren, and together they approached the bank. The lookout man saw them and ran away. Warren and Delaino went into the bank and confronted the other man, who tried to pull a gun on them, but Chief Warren had already pulled his first. By that time, much of the town's population was awake and looking for the first would-be

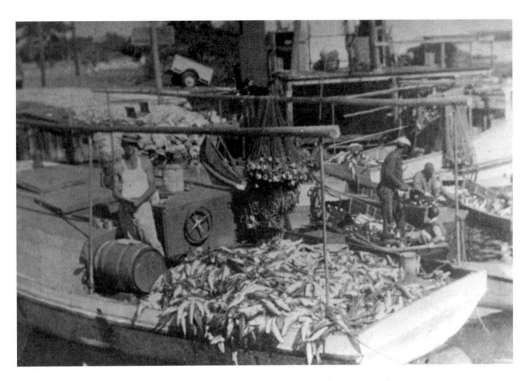

Mullet fishing was still quite good in the 1940s. *Image courtesy of Lindon Lindsey.*

robber. They soon found him hiding under a house near the Number One Bridge. Both men were tried and convicted in federal court.

Sheriff Robbins pointed out that he and one or two deputies had to work the whole of Levy County and supply their own vehicles. One of his deputies in Cedar Key was Johnny Rowland. The men were on a fee system; if they did not make any cases in a particular month, they did not get paid.

HURRICANE

On June 24, 1945, a category one hurricane, which had weakened from a category three storm, made landfall around Crystal River or Kings Bay below Cedar Key with winds of eighty-one to ninety-two miles per hour. Unlike previous storms (in 1888, 1896 and 1935), Cedar Key was on the good side of the storm, where the winds were the weakest. From 1950 on, the hurricanes would be named.

1950–1959

THE BIG DOCK

A fire on the morning of April 16, 1950, destroyed some five hundred feet of the dock at Cedar Key as well as four of the eight fish houses next to the dock. Officials from Levy County, cognizant of how important the dock was to the economy of Cedar Key, agreed to reconstruct the dock from C Street to D Street, then along the railroad right-of-way. The new dock would be cement.

HURRICANES

In 1950, local weatherman C.C. Whidden received weather reports by Western Union about an approaching hurricane and hoisted flags up a fifty-foot pole on the hill where he lived for everyone to see. He had flags that corresponded to different situations—including a flag for an approaching hurricane and another for a northwester—all of which his neighbors knew well.

When the 1950 hurricane, misnamed Easy, hit in the early morning hours of September 6, most of the people still in Cedar Key abandoned their homes and took shelter in the Cedar Key High School. People holding hand-held wind gauges said that the winds of the storm reached 185 miles an hour. It broke the wind gauge of one man at 176 miles per hour, and one person estimated that the storm dumped forty inches of rain on the town. Amazingly, no one was killed or seriously injured in the storm. However, Associated Press reports said that only fifteen of the town's two hundred homes were habitable after the hurricane. It also destroyed the building of Christ Episcopal Church.

Most of the waterfront fish houses that had survived a fire in April were destroyed by the wind that September. The hurricane struck Cedar Key for seventeen hours and blew the roof off the Island Hotel, filling the upstairs rooms with water. The stains on the

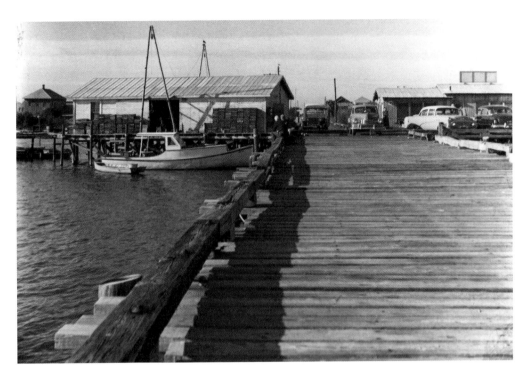

The Big Dock had been wooden for many years. *Image courtesy of Lindon Lindsey.*

King Neptune painting in the bar were caused by water draining from upstairs. Workers bore holes in the floors of the upstairs rooms in order to let the water drain out of them. The 1950 hurricane also destroyed all the books in the Episcopal Parish House, which had housed the town's first lending library.

The telephone operators at that time were Florence (Hughes) Wilder and Florence Whitman. The women received high praise from many when they braved the fury of that hurricane and kept the lines open during the storm until the wind blew the windows out of their building, water poured through the roof and the waters of the gulf entered the building. At that point, the operators sought higher ground. The bank roof leaked so badly that the dial equipment for the telephone system, housed in the upstairs room of the building, got wet and the lines to Gainesville went dead. Southern Bell sent workmen by boat to restore service, and they were able to put a line in and install a telephone at the schoolhouse, where most people had gone to seek shelter. The telephone operators took turns manning the phone, making calls to families and friends on the mainland to let them know how everyone was doing in Cedar Key. It took three days for the Southern Bell workmen to dry out the lines, restore service and make the switch to dial phones. At that point, the company transferred all four local operators to Gainesville because they were no longer needed in Cedar Key once the switch to dial phones was made.

Mayor G.A. Birdsey reported that 90 percent of the fishing boats and nets were destroyed. The fiber factory that Dr. Dan Andrews owned and which employed thirty-five people was badly damaged and operated on a limited basis after that until it ceased

operation in 1952. A fiber and brush factory exhibit is on display in the Andrews House behind the Cedar Key Historical Museum. Dr. John Andrews has used fiber left from the original operation to make replicas of the original Donax-whisk brushes and has donated them to the Cedar Key Historical Museum for sale.

After that hurricane, volunteers came from surrounding communities, including as far away as Gainesville, to repair the damaged businesses and houses. With the concerted effort of many, the town quickly returned to normal.

SEAHORSE KEY

In 1952, the University of Florida received a twenty-year permit to establish a marine laboratory on Seahorse Key. In 1953, the university established the Seahorse Key Marine Laboratory that would eventually attract international scholars as well as undergraduate and graduate students involved in many studies.

BEFORE AND AFTER THE KOREAN CONFLICT

The Veterans' Memorial near City Hall lists the local residents who served in different wars, including the Korean Conflict. A star next to a name indicates that the person died in the conflict.

After the conflict ended, civil defense authorities still wanted volunteers to man observation posts in this country to note what airplanes were flying in each area. In Cedar Key, P.H. Day and Mr. Birdsey built an observation tower, from which volunteers observed all the planes flying in the vicinity twenty-four hours a day, seven days a week. The most dependable volunteer was Alberta Smith Birdsey, who spent more time than anyone else in the work. The strangest incident occurred when an observer noticed lights moving very fast back and forth across the water before shooting straight up into the air and then down rapidly into the water. The observer reported the phenomenon to an air force official, who would not reveal the identity of the lights.

After the disbanding of the local Ground Observation Corps in Cedar Key, Sammy Lindsey used the observation tower as a radio station. He was a disc jockey who liked to talk to the fishermen as they went in and out of the local waterways. The problem was that he had loudspeakers at the facility, and everyone around could hear what he was saying whether they wanted to or not.

HAVEN FOR SINUS SUFFERERS

In the 1950s, Cedar Key promoters advertised the town as a place where sinus sufferers could find relief. They argued that because the waters of the Gulf of Mexico move in the area from west to east and then to the south, when the northern or cooler waters of

The University of Florida had a dock built at Seahorse Key for a marine laboratory. *Image courtesy of Kevin M. McCarthy.*

the gulf reach Seahorse Key, they are diverted out into the gulf, while the warm water from the south moves up to the same island and remains there, giving off warmth and creating a balmy or springtime feel. Those conditions plus the high elevation of the islands and the pollen-free air are conducive to the relief of sinus problems.

CHURCHES

Bishop Juhan sent the newly ordained Reverend Robert Cowling to Christ Episcopal Church in 1950 as the first resident priest there in many years. Three months later, a severe hurricane hit the town and the church building. Bishop Juhan spread the news and photographs of the destruction to churches throughout the state, and they generously contributed to the rebuilding of the facility, including repairing the damaged parish house with lumber from the wrecked church. The new building, in a Spanish-mission style, had the altar at the eastern end instead of at the northern end as in the two previous buildings. Workers took propellers from boats damaged in that 1950 hurricane and fashioned them into a cross, which they put on top of the new building and dedicated to the memory of Mrs. Elizabeth Andrews, longtime president of the Churchwomen of Christ Church. The church building was finished in 1952. After five years of service in Cedar Key, Mr. Cowling was assigned elsewhere, and Reverend Harry Babbitt became the new pastor. In 1958, Reverend Babbitt was assigned elsewhere, and

Workers repaired the steeple of Christ Episcopal Church after the 1950 hurricane. *Image courtesy of Kevin M. McCarthy.*

the recently installed bishop, Right Reverend Edward Hamilton West, sent Reverend John M. Haynes to serve in Cedar Key.

BUILDINGS AND FACILITIES

The building situation became so acute in Cedar Key in the early 1950s that some entrepreneurs resorted to unusual methods, including the placement of three railroad cars near C Street and the county pier by Mr. W.W. Hale in 1951. The hardware merchant bought the railroad cars from St. Petersburg Transit Company and converted two of them into a roadside café and a third one into a dwelling.

In 1953, local officials opened a man-made beach at the end of Second Street, a location that would be popular with attendees at the annual fall and spring festivals, where chicken and fish dinners were sold. Before the beach was opened, officials discovered that a technicality of Florida law would not allow the city to obtain funding for a park at a location not directly connected to a state road. The local senator, W. Randolph Hodges, one of the most powerful men in the state senate, was able to have State Road 24 diverted down Second Street to the beach site, and that allowed the city to get state funding for the beach. It helped to have influential friends in high places of government.

In 1956, R.C. Mullis of High Springs opened up a new theater in Cedar Key; the first film shown was MGM's "The Prodigal," a cinemascope picture in color. The theater, which could hold 130 patrons, would operate six nights a week, Monday through Saturday, with each film running for two days.

Around 1958, Marie and Webster Johnson built Johnson's Restaurant—on Dock Street, where the Seabreeze is today—and ran it for twelve years. Originally it was to be simply a bait-and-tackle shop that also sold snacks to people going out on their boats, but the Johnsons changed it into a good restaurant. Other restaurants that preceded Johnson's include Mrs. Alford's Greasy Spoon, Annie Sheffield's, Leslie's (Richburg) Café and Mrs. Wilkerson's Restaurant.

In 1959, Margaret and Philip Thomas, who owned the Thomas Hotel (now known as the Thomas Center) in Gainesville, built the famous stilt house (sometimes nicknamed the Honeymoon Cottage). The stilt house is out in the gulf a short ways from land, but is connected by a wooden walkway. In 1985, Hurricane Elena destroyed the walkway and did much damage to the wooden house, but it has become the most-photographed building in town and once graced the side patches of the local police department uniforms.

FISHING AND CRABBING

Fishing remained the most important source of income for area residents, who had some 150 boats operating out of Cedar Key, but the fluctuations in the market kept many

The Seaside Park would host many seafood festivals over the years. *Image courtesy of Kevin M. McCarthy.*

The Honeymoon Cottage was a popular subject for photographers. *Image courtesy of Kevin M. McCarthy.*

of those boats tied up during the hard times. The fishing season for the hook-and-line fisherman was usually from April to September, but the main season for mullet fishing was from July to March. Cedar Key had five wholesale fish dealers. The usual price paid to fishermen for mullet was twelve cents a pound; for trout, twenty-three cents a pound; other bottom fish, for example red fish and sheepshead, twelve cents a pound. Most people would not buy mullet because they thought it was a poor-tasting fish, one used mostly for bait. To counteract that feeling, Senator Hodges from Cedar Key had the name of the fish changed to *lisa*, the Spanish name for mullet, to make it sound better, but that did not help much, and the ploy was discontinued by 1963.

Every year, mullet fishermen from Cedar Key would go to the ten thousand islands in South Florida for mackerel and pompano from January to April because fish were scarce in the Cedar Key area. They would sell the fish down there before returning to Cedar Key.

Returning servicemen, who had seen the popularity of crabs in other cities and states, thought that crabbing would be more popular than mullet fishing and began to harvest blue crabs in local waters. A seafood company from Maryland leased the old fiber warehouse and turned it into a crab-processing plant, Cedar Key Seafoods, which opened in 1955 and processed blue crabs. In 1976, the owners of the plant moved it to Otter Creek, where it did well.

CRIME

After many months without serious crime (the last hold-up attempt in Cedar Key had occurred in 1947 when two men were caught trying to rob the bank), a robber was killed in a high-speed chase in 1959. Twenty-four-year-old Huey Long Cannon of Chiefland had begun the day by robbing the Chiefland Theatre of about thirty-five dollars, then drove to Cedar Key, where he robbed Mrs. Leone Brown, at gunpoint, of one hundred dollars. As he fled the store, Mrs. Brown ran outside and gave the alarm to City Marshall Sam Perryman, who gave chase at speeds up to ninety miles per hour. As Cannon sped out of Cedar Key, he failed to make a curve, hit a power line and went over a twelve-foot embankment into a lagoon, where he died. Perryman and Sheriff Jimmie Turner found a revolver and wads of bills on Cannon's body when they recovered it from the wreck.

PEOPLE

In 1952, voters elected W. Randolph Hodges to the Florida Senate to represent the twenty-first district of Levy, Gilchrist and Dixie counties. He was a senator for three terms (twelve years) and served as president pro tempore of the Senate (1959) and president of the Florida State Senate (1961). Born in Cedar Key on February 5, 1914, and living most of his life in the home his father had built around the turn of the century, he graduated from Cedar Key High School (1932) and attended the University

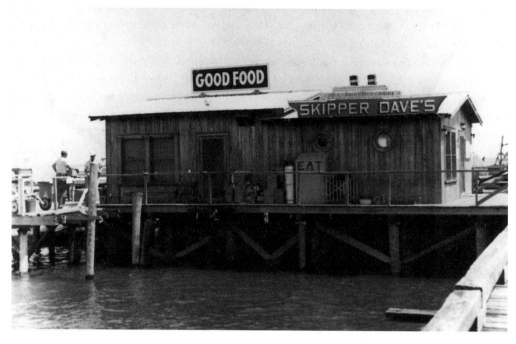

Skipper Dave's Restaurant was on the Big Dock. *Image courtesy of Lindon Lindsey.*

Mr. Whitman organized his artifacts very carefully. *Image courtesy of Kevin M. McCarthy.*

of Florida before returning to Cedar Key. He married Mildred Yearty from Otter Creek (1933) and began a relationship that lasted seventy-two years.

He worked for a while as a commercial fisherman, operated a fish house, bought the local ice plant (1940s), manufactured ice for fishermen for some fifteen years and owned an appliance and marine store. Following the footsteps of his father, who had served as a Levy County commissioner for many years, Randolph served ten years as a Levy County commissioner and two terms as mayor of Cedar Key.

In 1956, six years after the disastrous hurricane that destroyed much of the town, Gertrude Teas arrived with boxes of books and tried to start a rental library in a Second Street bookshop run by Louise Bowerman. That effort did not succeed, but it did not deter Ms. Teas.

The mayors of Cedar Key in the 1950s were George Birdsey (1950–1951), W. Randolph Hodges Jr. (1951–1952), William E. Delaino Sr. (1952–1956) and George Birdsey (1956–1962).

St. Clair Whitman, the longtime collector of artifacts dealing with the history of Cedar Key, died in 1959 at the age of ninety-one and is buried near the entrance of the Cedar Key Cemetery near his beloved wife, Ellen "Nellie" Olivia Webster Whitman. Much of his collection became the foundation of the collection for the state museum, which opened in 1962. His descendants donated his wood-frame house at Goose Cove to the state museum in 1991. A citizens' support organization had it moved to the museum site, and it opened to the public in 2003. Early pioneer Henry Hale had built the house on a Timucuan Mound in 1890. Whitman, who bought it in 1920, designed much of the equipment in the Standard Manufacturing Company, which produced brooms. He worked for the company for forty years before he retired to work on his museum. The restored house can give visitors a view of what life was like in Cedar Key in the 1920s and 1930s.

1960–1969

THE BIG DOCK

Records indicate that workers repaired and renovated the Big Dock at Cedar Key in 1963. They built a concrete dock two years later at a cost of over four hundred thousand dollars.

VIETNAM WAR

Over three dozen local citizens served in the Vietnam War, a fact that is noted on the monument that local officials erected in 1994 outside the City Hall on Second Street.

SIDEWALK ARTS FESTIVAL

Nineteen sixty-four saw the first of the annual spring arts festivals that would attract thousands of weekend visitors to the many pieces of art exhibited along Second (Main) Street. Together with the fall fish fry, the festivals would bring in much-needed money to the community and expose the beauty of Cedar Key to people who otherwise might never have visited.

CEDAR KEY HIGH SCHOOL

The principals of the school in the 1960s were Sidney D. Padgett (1945–1962), B.R. Campbell (1962–1965), Meryl Fielding (1965–1966) and Wyeth A. Read (1966–1970).

When the Cedar Key Sharks boys' basketball team won the Class C State Basketball Championship in 1965, their high school became the first Levy County team to win a

state championship. The Sharks beat Hilliard, which had been in the state tournament for the previous fifteen years, in an exciting 69–65 game. The Sharks had gone to the final by beating Lake Placid in a 62–55 overtime game.

That championship, won by a school that ranked consistently as the smallest public high school in the state, fueled a competitive edge that spanned decades. Because basketball is the only sport played by many students at the school, and they play it all year round, they played with a fierceness that sometimes surprised the students from larger schools. For years, the sign leading into the city welcomed visitors this way: "Cedar Key. Home of the Sharks. 1965 Class C Basketball Champs." Students liked to repeat the mantra: "Pride runs deep when you're a shark."

Seahorse Key

In 1967, the University of Florida leased the lighthouse and the adjacent area on Seahorse Key, which belongs to the federal government, to help its marine research program. In the 1930s until the 1950s, Mr. Addison Pound, a retired U.S. Navy captain, had leased it. The protected harbor is away from the open gulf and usually so safe from hurricanes that boat owners sometimes have their larger boats taken there to ride out the storm. Even when a storm lashes the town of Cedar Key, the harbor at Seahorse Key remains relatively unscathed.

Peace Corps Training Site

In 1967, forty-one Peace Corps volunteers trained in Cedar Key along with their international faculty before going to Brazil. Federal officials chose the Florida town because it was the same size, residents caught the same kind of fish, and it had the same weather as the Brazilian community where the young Americans would work for two years. At first, the community was apprehensive about the project, especially when the volunteers included two African Americans, who ended up staying on the town's outskirts in a motel run by Mrs. John Seaton. In order to ease tensions, the volunteers, some of whom were "hippie-looking" with long hair and strange clothes, invited the town residents to a party. Much of the town showed up and came to know and accept the volunteers as decent young people.

It took adjusting on both sides. At first, only the Island Hotel under Bessie Gibbs, who also happened to be the mayor of the town at that time, would serve the African Americans. But then Skipper Dave's on the docks began serving them. As one newspaper writer summed up the whole experience at the end of the three-month training period: "Because of the sojourn here of forty-one volunteers training in the nation's Peace Corps to help the world's underdeveloped nations, the talk in Cedar Key never will be quite the same."

Above: The water tower proudly proclaims the nickname of the Cedar Key High School athletic teams. *Image courtesy of Kevin M. McCarthy.*

Left: The lighthouse has been well maintained over the years. *Image courtesy of Lindon Lindsey.*

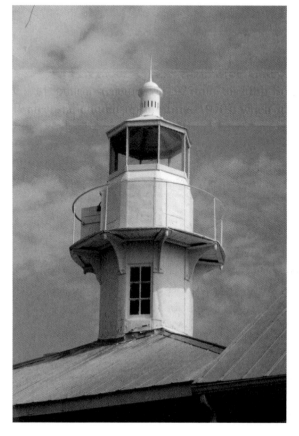

Opposite: Fishermen would dry out their nets all around town, including on the beach. *Image courtesy of Lindon Lindsey.*

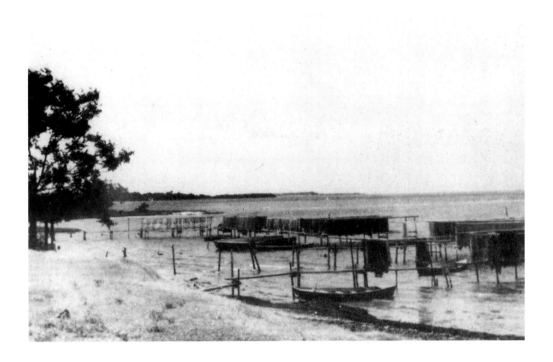

BUILDINGS

The Island Hotel continued to thrive. After Loyal "Gibby" Gibbs died in 1962, he was cremated and his ashes were placed behind the bar for a day while Bessie and friends waited for the tide to change so they could scatter Gibby's remains at sea. Bessie continued to operate the Island Hotel and take a very active role in community affairs, serving as a city commissioner, member of the City Planning Board, city judge and mayor. Along with Sally Tileston, she helped organize the Cedar Key Arts Festival in 1964 to raise money for community projects. The festival, which had only twenty-five exhibitors that first year, would attract hundreds of exhibitors and thousands of visitors to the island.

The Cedar Key State Museum opened in 1962 on a small hill overlooking the Gulf of Mexico to the northwest of the town. It contains many artifacts collected by the late St. Clair Whitman, a longtime resident who had moved to Cedar Key in 1882.

When the owners of his house, which had stood at the end of Sixth Street since Henry Hale built it in 1890, announced that they would tear it down to make room for townhouses, officials moved it to the site of the museum in 1991 and opened it to the public in 2003. The museum contains much of what he collected over the years. He lived in the house from when he bought it in 1921 until 1959. Elizabeth Ehrbar has been involved with both the State Museum and the Cedar Key Historical Museum, where she has created exhibits, just as she has in other museums and buildings around the state. Near the state museum is Rye Key, which takes its name from the 1823 birthplace (Rye, New Hampshire) of local resident John E. Johnson, who lived there in the 1850s.

LOCAL OFFICIAL

After serving in the Florida Senate since 1952, including a stint as president of the Florida State Senate (1961), W. Randolph Hodges was appointed by Governor Ferris Bryant and the Florida Cabinet after the 1961 legislative session to serve as director of the Florida Department of Natural Resources. In that position, he and his family lived in Tallahassee for thirteen years. He also served as director of the newly established Department of Natural Resources. When he retired from state government in 1974, he and his wife returned to their family home in Cedar Key. There he raised cattle on the nearby Rosewood Farm on the mainland; he also worked in Tallahassee as a lobbyist representing Pompano Park Harness Race Track.

HURRICANES

In the 1960s, Hurricane Dora (1964) and Hurricane Alma (1966) hit the area. During the bad storms, those that caused flooding and cut access to the outside world, Red Cross officials set up operations at Cedar Key High School to serve food to those in need.

CHURCHES

When Reverend John Haynes was reassigned around 1962, a retired Anglican clergyman, Reverend C.J. Ryley, became the interim pastor at Christ Episcopal Church. In June 1962, Reverend Henry Hoyt became the new pastor both there and at St. Barnabas Church in Williston. In 1965, Reverend Hoyt was assigned elsewhere, and a retired minister, Reverend A.F. Traverse, replaced him. Later that year, William McLemore was assigned to Christ Church in Cedar Key. In 1968, the church marked its one-hundredth year in Cedar Key.

In 1965, the congregation of the Cedar Key First Baptist Church built an educational building on the grounds of its church for Sunday school classrooms and recreational programs. Two years later, the congregation air-conditioned its church and established a library with Mrs. Laura Byrd as librarian.

PEOPLE AND ORGANIZATIONS

In 1960, Florida Governor T. LeRoy Collins appointed Gertrude Teas to the Regional Library Board, and she served until 1975. In attempting to secure a library for Cedar Key, she had to settle for the Central Florida Regional Library created by the Levy County Commission. County officials considered Cedar Key too small to support a regional library, but the community gained good access to a library system through the regional library concept.

Above: The restored Whitman House is on the grounds of the state museum. *Image courtesy of Kevin M. McCarthy.*

Right: The crabs would be unloaded and weighed at the end of a long day. *Image courtesy of Lindon Lindsey.*

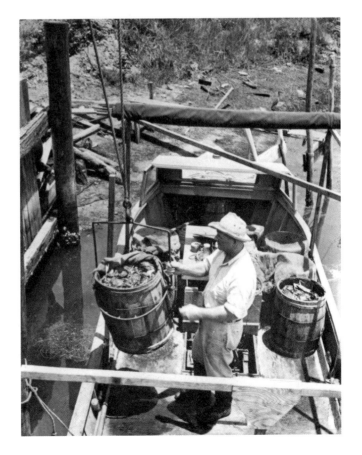

Ms. Teas, Jean Billingsley, Ida Hale and Rosalie Sills convinced enough people to establish a local chapter of the national Friends of the Library organization in 1980. When library space became a problem, that chapter raised money to build an addition to the library, an addition that provided extra space for reading and research.

In 1960, forty-nine women established the Cedar Key Woman's Club with Mrs. Charles Bowerman the first president. Among its activities were to conduct a drive for the Mental Health Association, have a reception and provide gifts for the senior class at Cedar Key High School, operate Trash and Treasures and participate in civic drives.

In 1962, Captain T. (Texas) R. (Ruff) Hodges died. He was born in 1874 at Hickory Island and was the last survivor of eleven children of Dr. and Mrs. A.E. Hodges, pioneer citizens of the county. T.R. Hodges attended the East Florida Seminary in Gainesville and worked in the newspaper business in Cedar Key, Bronson, Starke and Jacksonville. In 1914, he helped organize the first Shellfish Commission of Florida to protect saltwater fish and shellfish and to build up the industry to one of the largest in the state. For thirty years he operated an insurance agency and practiced law in Cedar Key.

Sally Tileston and Dottie Comfort published *Cedar Key Legends* in 1967. The book of area folklore includes a tale about a headless horseman on Seahorse Key.

In 1968, the local chapter of the Lions Club was established. The club sponsored the fall seafood festival, contributed to a sight-conservation program, sponsored a summer camp for visually handicapped children and organized a beauty pageant, parade and competitive programs. Affiliated with the Lions Club was a Lioness Club, which received its charter in 1981 and engaged in fund-raising for the community, for example, by helping the Cedar Key girls' basketball team buy new uniforms in the 1980s. Like the Lions, the Lioness Club is not a social group, but a service organization devoted to helping the blind, deaf, indigent and other less-fortunate persons.

In 1969, a new city charter made the city council members city commissioners. The mayor would be a city commissioner as well. Each of the five commissioners supervised one of the city's departments, for example, city hall, the fire department and the police department.

The mayors of Cedar Key in the 1960s were George Birdsey (1956–1962), Jesse Quitman Hodges (1962–1966), Bessie Gibbs (1966–1968) and Nathan Fine (1968–1970).

Chapter Fifteen

1970–1979

CEDAR KEY SCRUB

In 1971, the state of Florida bought the land between Highways 326 and 347 for what became the Cedar Key Scrub State Reserve, better known simply as "the Scrub." A reserve differs from a preserve in that the former allows hunting in season, some agricultural work and limited timbering. A preserve allows no such activities. The Scrub blends into the Waccasassa Bay State Preserve beyond Cedar Key and south and then westward along the Gulf of Mexico almost to Yankeetown. The Scrub had ranger-led overnight canoe trips with authorized camping in the spring. Endangered, threatened or other species in the Scrub include the bald eagle, black bear, deer, Florida panther, fox, gators, gopher tortoises, manatees, scrub jays, wild pigs and many kinds of birds. The wild turkey of Florida breeds there. The ghost town of Lukens, which was thriving in the 1920s, is part of the Scrub.

HURRICANES, PEOPLE AND EVENTS

Agnes, a major hurricane, hit the area in 1972.

The widowed Bessie Gibbs continued to run the Island Hotel, but painful arthritis and a spinal disease took a toll, finally forcing her into a wheelchair. She sold the Island Hotel to Charles and Shirley English in 1973 and continued to live in Cedar Key, in a small wooden house along State Road 24, until she died in a house fire in 1975. Her remains were cremated and spread on the waters of the gulf that she had so dearly loved. She is honored by a plaque outside the hotel and by a memorial marker at the entrance to the Cedar Key Cemetery. She was the one who founded the Cedar Key Sidewalk Art Festival, which has brought so many visitors to the city. Old-timers who remember Bessie often have stories with which they regale the newcomers. Her most famous one-liner was probably that "Cedar Key is a way of life."

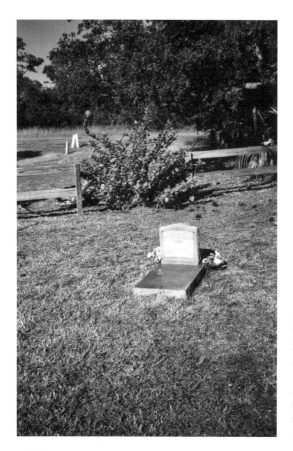

Left: The memorial marker to Bessie Gibbs is at the entrance to the town's main cemetery. *Image courtesy of Kevin M. McCarthy.*

Below: The building that Gertrude Teas sold to the Cedar Key Historical Society houses the museum of the society. *Image courtesy of Kevin M. McCarthy.*

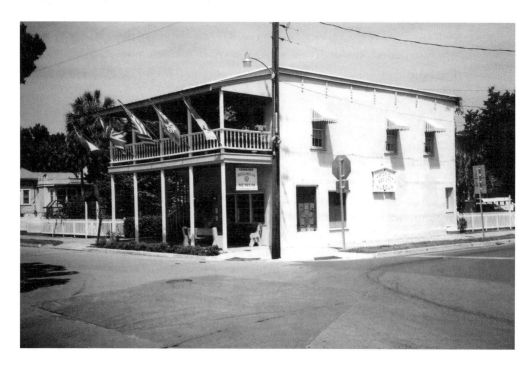

Charles and Shirley English operated the Island Hotel until 1978, when they sold it to German-born Harold Nabors, who remodeled the bar and opened the annex garden to outdoor entertainment.

A fire in March 1975 destroyed the Porthole Bar and Lounge in Cedar Key. Mrs. Mary Arline had operated the lounge, which had been called the L&M Bar and Lounge when operated by Lawrence and Melrose Clark. The thick, coquina-type walls of the more than one-hundred-year-old building managed to confine the fire before it spread to adjoining buildings. Fire units from Chiefland, Inglis, Otter Creek and Trenton helped the Cedar Key Fire Department and led to recommendations that the city have a reciprocal agreement for fire fighting with other towns.

Gertrude Teas sold the property that is located on the northwest corner of State Road 24 and Second Street to the Cedar Key Historical Society for a bargain price in 1978. The U.S. Army had deeded the land there to Thomas R. Parsons in 1853; then David Yulee and the Florida Railroad Company owned the property in 1855. The president of the Historical Society in 1978, Polly Pillsbury, accepted the property, which would later be the site of the museum run by the historical society.

About forty commercial fishermen worked out of Cedar Key in the 1970s. They brought their catch to the Cedar Key Fish and Oyster Co. owned and managed by Henry Brown. Mike Davis, a former net fisherman who is descended from generations of local fishermen, bought the business in the late 1980s. During the better years, the company grossed between one and two million dollars a year from fish. About 10 percent of the fish, oysters and crabs were sold to local restaurants, 10 percent were sold in the company store and the rest were shipped to outside markets.

Oyster harvesting continued to grow in importance. Groups such as the Levy County Watermen's Association worked closely with local fishermen, carefully transplanting thousands of small oysters from exposed tidal flats near Cedar Key to deeper water offshore, which would allow the oysters to develop normally and grow larger. A favorite place for the transplanting was the deep water near Corrigan's Reef three miles from Cedar Key.

The city's sewer was overcapacity in the early 1970s, so there was a moratorium on new hookups to the sewer. Finally, in 1976, the Cedar Key Special Water and Sewer District officials were able to complete a project to expand and modernize the water and sewer systems in the city. Before then, the old sewage disposal system was a huge septic tank on the beach near the oldest house in town, but once the new plant was functioning, workers were able to fill the old tank with sand. Pipes had pumped out all the effluent into the gulf until the new sewer system was built.

The city commission barred construction of new buildings more than three stories in height, using as an excuse the town's lack of fire-fighting equipment that could handle high-rise fires. In response, newcomers pressured the commission to retire their 1946 fire truck and buy a new one that could handle different types of fires. Officials then tried to organize a volunteer fire department that was trained in modern fire-fighting techniques, but the volunteers refused to do the hard work of washing down the fire truck and rolling up the hoses. The fire chief, K. Muchler, a retired fireman from Buffalo,

The art festival, photographed here in 1977, would attract thousands of visitors and bring in much-needed income to the town. *Image courtesy of Lindon Lindsey.*

New York, who had recently moved to Cedar Key, tried to instill good working habits among the volunteers, but in the end quit, partly out of frustration and partly because the locals considered him too much of an outsider to tell the volunteers what to do. The volunteer fire corps soon disbanded, and the town resumed its old ways of having everyone respond to fires when the alarm sounded.

Among the organizations formed in the 1970s was the Cedar Keyhole, a cooperative organized in April 1978 and consisting of local artists and craftspersons. It may have been the first art gallery in Cedar Key and occupied what had been an auto-parts store.

ANNUAL CEDAR KEY ARTS FESTIVAL

Beginning in 1964, thousands of visitors attended the arts festival each spring, but the 1975 festival soured some local residents on continuing the tradition. They argued that too many people and too many cars and too much garbage put a huge strain on the small community during the two days of the festival. The 1974 festival had 240 exhibitors and 35,000 people; the 1975 festival had 400 exhibitors and over 100,000 people. As a compromise, organizers for the 1976 festival cut down the number of exhibitors from hundreds to a more manageable 169, allowed only paintings and sculpture and not crafts and added to the two-man police force. Mayor Richard Zeigler and Police Chief George Daniels were pleased at the smaller festival that attracted about 35,000 visitors, and

The area near the fishing dock slowly attracted more and more businesses. *Image courtesy of Lindon Lindsey.*

festival chairman Fran Hathcox and festival treasurer Loretta Myrick were pleased with the numbers. In their major moneymaking project of the year, the Lions Club served 2,237 people at $2.50 per head with 2,050 pounds of mullet, 250 pounds of hushpuppy mix, and fifteen bushels of oysters. The Lions Club used many of the proceeds from each year's festival to buy eyeglasses for those who could not afford them.

Festival planners made changes for the next year's festival, including designated parking places for artists, more exhibitors, more advertising, more trash cans, a leash law and a date that did not conflict with other area events, like the 1976 Lawtey Bluegrass Festival and the Dylan-Baez concert.

Cedar Key Historical Society

Local residents interested in preserving the history of the area incorporated the Cedar Key Historical Society in 1977. The founder and first president of the organization was Polly Pillsbury. Such people were instrumental in nominating the Cedar Keys Historical District, including the islands of Atsena Otie and Seahorse Key, to the National Register of Historic Places. One of the early members of the society and a writer about the history of the area, Charles Fishburne Jr., bought one thousand cedar tree seedlings in 1979 and donated them to the society, which in turn gave them free to anyone who would plant them in Cedar Key, the town that took its name from the tree. The society also produced the very useful *Historic Old Cedar Key: A Walking Tour* in 1987 (revised 1999).

CRIME

In 1978, law-enforcement officers arrested three men attempting to smuggle in marijuana near Shell Mound—an isolated part of the coast north of Cedar Key—when their drug-laden boat, *Way Out*, became grounded. The officers confiscated over six hundred bales of marijuana from the boat and in nearby waters. The drugs were worth over $10 million at the time. It would not be the last time smugglers attempted to bring in drugs from ships offshore. Officers took the marijuana to the landfill near Bronson and burned it. From time to time, law-enforcement officers, using planes to spot suspicious areas, found marijuana growing on land in isolated parts of Levy County and arrested those involved in the cultivation and sale of the drug.

CEDAR KEY HIGH SCHOOL

What may have been the school's first reunion of particular graduating classes (1984 would see the first reunion of all the graduates of the school) occurred in 1979 for the graduates of the classes of 1953, 1954 and 1955.

The principals of the school during that decade were Wyeth A. Read (1966–1970), Henry Powell (1970–1978) and Elmer Ball (1978–1980).

PUBLIC LIBRARY

By 1979, the Cedar Key Public Library had a bookmobile service providing books once a month to outlying areas, was able to take damaged books to Ocala for repair and processing, supplied books in Braille and offered a full range of books, records and educational programs to the public. The library had the largest circulation of any library in Levy County.

PEOPLE

In the 1970s, author George H. Walton lived in the house on stilts, which became the most frequently photographed structure in the city and which he called "Shark Tooth Shoal." The seventy-nine-year-old was the author of such works as *The Wasted Generation* (1965), *The Tarnished Shield: A Report on Today's Army* (1973) and *Captain Madam* (1974), as well as co-author of *Faint the Trumpet Sounds: The Life and Trial of Major Reno* (1966).

The mayors of Cedar Key in the 1970s were Nathan Fine (1968–1970), Henry J. Brown (1970–1971), James W. Bishop (1971–1972), Jesse Quitman Hodges (1972–1974), Charles W. "Buddy" Rogers Jr. (1974–1975), Richard A. Zeigler (1975–1976), Lonnie Herald Turner (1976–1977), Charles W. "Buddy" Rogers Jr. (1977–1978), Lonnie Herald Turner (1978–1979) and Leif Johannesen (1979–1980).

CEDAR KEY HIGH SCHOOL

In 1980, the Levy County School Board closed Cedar Key High School (CKHS), the smallest public high school in Florida, because the school board did not have enough money to fund the teachers at CKHS and could not justify spending money for so few students. That meant that thirty-two CKHS students had to be bused to Bronson High School or Chiefland High School, adding three hours of bus commuting to their day. The local school would retain kindergarten through eighth grade, but not the upper grades. Part of the problem was that the federal office of civil rights in Atlanta had filed a complaint that the county was not complying with Title IX of the Civil Rights Act and that all schools in the county must provide sports and physical education programs equally for both boys and girls. School board members argued that, if they did not close CKHS, the county would be in danger of losing all federal funds to the school system. The school superintendent said that he could not justify keeping the school open because the enrollment was decreasing. School Board member C.T. "Ted" Alexander, a resident of Cedar Key, led the fight to reopen the school, but could not garner support from other school board members. Most agreed that the controversy over the closing of the school brought much of the town together in a way that was seldom seen before or after.

In 1981, Cedar Key High School (CKHS) reopened after the state legislature passed a bill, introduced by State Representative Gene Hodges (D-Cedar Key), himself a 1954 graduate of CKHS, to provide money for the county to reopen the school. The bill, designed to provide money for small isolated schools, stipulated that a school had to meet three criteria to receive funds. It had to have at least twenty-eight students, the school board had to be levying the maximum discretionary millage and the students had to score at a level that was equal to or above the average on statewide tests. That year, CKHS was the only school in Florida to meet all three criteria.

In 1984, at the first-ever reunion of all the graduates of the school, officials announced that 480 students had graduated from CKHS from 1924 to 1984. Compiling that list

The Hearn cemetery memorial is near the high school. *Image courtesy of Kevin M. McCarthy.*

was difficult because the 1943 fire that destroyed the school also destroyed most of the school records. That 1984 reunion attracted over 650 people, including 250 who had graduated from the school. In 1984, for the first time in many years, the Cedar Key School had a Parent-Teacher Association, organized by Beth Davis and Dian Taylor.

The principals of the school that decade were Elmer Ball (1978–1980), Alvis "Bubba" Lane Jr. (1980–1981), Rob Ice (1981–1985), Mary Wells (1985–1989) and Sheila Bridges (1989–1990).

HEARN CEMETERY PLOT

In 1982, the Cedar Key Island 4-H Club, under the direction of president Daphne Beckham and of long-time teacher Brenda Coulter, dedicated the Hearn Cemetery plot on the grounds of Cedar Key High School. The marble headstone, which local organizations provided, states simply of the three Hearns buried there: "Lived Here and Supported Public Schools." Eliza Hearn may have lived nearby and, on her death in 1910, willed the property to the city.

CIVIL AIR PATROL

The Cedar Key Squadron of the Civil Air Patrol (CAP) received its official charter in 1980. The CAP, the civilian auxiliary of the U.S. Air Force, assists in air search-and-

rescue work, as well as in local emergencies determined by the City Defense Office. CAP, which is composed of volunteers, maintains its own fleet of light airplanes for humanitarian purposes, including search and rescue, disaster relief on the local level and a program to interest young men and women in aviation.

GEORGE T. LEWIS AIRPORT

The unmanned George T. Lewis Airport is located in the middle of a residential subdivision, Piney Point. From the time when it was built in the 1930s until the present, much discussion has occurred about the facility. Should the runway be extended? What kind of lights should be placed nearby? What kind of restrictions do nearby homes have on what can be built there? Should the airport be moved inland—for example, to Rosewood— to have safer facilities, more space and fewer problems with neighbors? Private homes near the airport have caused legal problems. One resident built a hangar-size garage on the first floor to house his plane, even though such a hangar was against the law.

Although the airport, which some would call only an airstrip, is busiest during the fall and spring seafood and art festivals, planes do land and take off at other times, sometimes with people arriving for an evening meal. And at least one local resident, a commercial pilot, commuted by his own plane to the Orlando airport where he worked for Northwest Airlines.

For years, nearby residents Clyde Coulter and his nephew, Henry, maintained the airport. If incoming pilots flew near the Big Dock and wagged their wings, Henry's mother, Edna, would drive out to the airport and transport the plane's pilot and passengers into town.

Planes have hit trees at the end of the runway, and some planes have crashed into the sea, with a resulting loss of life. The runway, which is 2,400 feet long, does not meet the 2,500-foot length that the federal government requires for light aircraft. Because part of the north end is dedicated to car traffic, the runway is only effectively 1,777 feet long. A county road runs through the north end to give residents access to part of Piney Point.

WIND INSURANCE

In the 1980s, wind insurance was a major issue in Cedar Key. Nineteen eighty-five had been a bad year for hurricanes in the area, with Elena and Juan hitting Cedar Key and causing damage. After the storms, some insurance companies canceled insurance or refused to renew policies. Many people, including County Attorney Greg Beauchamp (who represented the city of Cedar Key), bankers, politicians like State Representative Gene Hodges, realtors and residents testified at hearings that the city's economy was being stifled by their inability to purchase windstorm insurance. For example, banks were unwilling to finance new mortgages because the owners could not protect their buildings against windstorm damage. In turn, realtors were unable to sell land.

Private planes park on the tarmac near the end of the runway at Cedar Key's small airport. *Image courtesy of Kevin M. McCarthy.*

After much discussion, State Insurance Commissioner Bill Gunter signed an order in 1986 that included Cedar Key in a state program, which guaranteed residents and businesses the right to purchase property insurance for windstorm damage. That meant that the city could join the Florida Windstorm Underwriting Association (FWUA), a non-profit organization composed of all the insurance companies in the state that sold property insurance. FWUA issued a policy for windstorm insurance in those areas where the state determined that windstorm insurance was not generally available and where the economy was being hurt because of that problem.

BUILDINGS AND FACILITIES

Harold Nabors sold the Island Hotel to Marcia Rogers in 1980. Soon afterwards, Ms. Rogers was diagnosed with cancer, which convinced her to transform the hotel into a vegetarian, alcohol-free bed-and-breakfast that prohibited the use of tobacco products. She closed the famous Neptune Bar and then turned it into a coffee and juice bar, causing much annoyance among some of the locals who considered the bar their personal watering hole. Her chef, Jahn McCumbers, provided a wide selection of dishes. Ms. Rogers convinced authorities to place the Island Hotel on the National Register of Historic Places in 1984. At the time, it was the only building in Levy County to have that distinction. One of the visitors to the hotel in the 1980s was Florida songwriter and balladeer Jimmy Buffett, who sometimes gave impromptu concerts in the Neptune Bar.

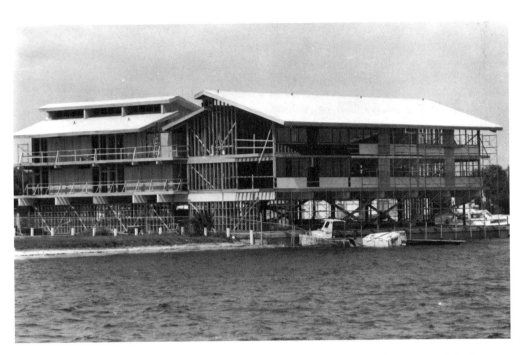

Small and large structures like these needed wind insurance. *Image courtesy of Kevin M. McCarthy.*

The Heron Restaurant opened in 1981 in the Hale Building at the northeast corner of the intersection of Second (Main) and D (State Road 24) Streets. The building, which F.E. Hale had built in 1880, had many uses: clothing store, grocery store, real estate office, bar, movie house, doctor's office and residential apartments. Because it was made of strong tabby concrete, it withstood many storms over the years. Its second-floor porch allowed residents a wonderful view of city activities.

In Cedar Key in 1982, local officials dedicated a heliport—the only one in Levy County and possibly the only one in the state used specifically for helicopter ambulances. Civil Air Patrol Commander Bill Almsteadt worked hard to help the city acquire the heliport.

The Cedar Key School library was renamed the Mary Ann Delaino Library in 1988 to honor a former teacher who devoted more than thirty years of her career to the school, including as a teacher (1938–1962) and librarian (1963–1967).

In 1985, the Cedar Key Garden Club, under the guidance of garden club president Annette Haven, built a six-sided open-air gazebo in the city park and, over time, planted shrubbery, including Texas sage, around the pavilion. At one of the fund-raisers to pay off the gazebo, local singer John Starr sang a song he wrote, "Tin Roof Shanties," about how progress was taking over the town, and Shelton Irwin sang "Cedar Key Sunset" about the mysterious charm that the sun exerts on people as it sets to the west of the town. The gazebo has served as a bandstand, entertainment center, festival-queen showcase and political-speech arena.

The garden club, which began in 1982 and joined the Florida Federation of Garden Clubs in 1983, also helped launch a beautification and anti-litter program for the city.

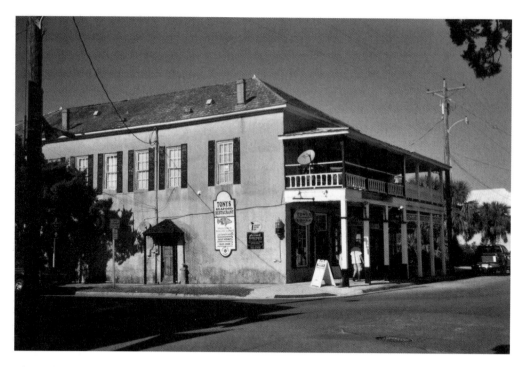

The Hale Building is in the center of Cedar Key. *Image courtesy of Kevin M. McCarthy.*

Under the direction of Dorothy Tyson, the club organized an annual citywide clean-up day, with which volunteers and the local Boy Scout troop helped.

EVENTS

The first annual Decemberfest occurred in 1985 and featured a Christmas parade, a juried crafts' show, sale of artwork and locally harvested and prepared seafood. It enabled local businesses to recoup some of the losses from Hurricane Elena.

NEW ADDITIONS

In 1983, local business people formed a chamber of commerce. Sidney Padgett, president of the Cedar Key branch of the Levy County State Bank, was elected interim director. There was a chamber of commerce in the early twentieth century, but it had stopped functioning by the 1980s.

In 1982, the Cedar Key Historical Society began publishing the *Beacon* about its activities to preserve and collect memorabilia about the history of the area. In 1984, publisher Norman E. Findlay and editor Mary A. Findlay began publishing a short-lived monthly newspaper: the *Cedar Key Log*. Around 1987, CG Desktop Publishing and Associates began publishing the *Cedar Key Island Review*, with Cindy Mullins as editor.

The open-air gazebo stands in the city park. *Image courtesy of Kevin M. McCarthy.*

Cedar Key began a volunteer fire department (1985), obtained its first ambulance (1988) and almost got its first stoplight. It seems that a man from a city in South Florida was replacing its old stoplights with new ones and gave Cedar Key a stoplight. Local officials, after thanking him, stored it someplace and it has never been used. The city had a very low crime rate and needed only a one-car, two-person police force.

The ambulance acquisition came about when the local Lions Club set up the Cedar Key Emergency Medical Services, Inc. (CKEMS) in 1986, after one of their fellow Lions, Peter Dehmer, died of a heart attack during a club dinner function. Fellow Lions members knew that emergency aid was at least an hour away and were unable to revive him in time. In those years, the city had no doctor, ambulance service was in Bronson or Chiefland and a helicopter ambulance was not always available because of emergencies elsewhere or the inability to land in Cedar Key because of low visibility after dark. Levy County commissioners leased a soon-to-be-retired ambulance to the group for a dollar a year. After local volunteers took first-responder courses in Ocala, the average response time to an emergency was reduced to less than ten minutes. The result was a number of saved lives. By 2006, an EMS unit was stationed on Highway 347 outside of Cedar Key.

The first artificial reef in Florida designed to serve both sport and commercial fishermen was built in 1985, about nine miles from Cedar Key out in the gulf. The reef was designed to provide a habitat for grouper and snapper, which sport fishermen sought, and for stone crabs, which commercial fishermen sought.

The Department of Natural Resources funded the project with a ten-thousand-dollar grant, money that could be spent only on transportation of materials, which meant

The fire department had several locations in town. *Image courtesy of Kevin M. McCarthy.*

that the project coordinators relied on donations of labor and material from local companies. Bill Lindberg, assistant professor in the Department of Fish and Aquaculture at the University of Florida, headed up the project. However, on Labor Day weekend, Hurricane Elena severely damaged the reef two weeks after it was finished. Some local people objected to the placement of man-made material in the gulf because they thought it would litter and trash the place, but the man-made structures attracted fish, which pleased the fishermen. At that time, all of the artificial reefs in Florida were designed to promote sport fishing by attracting game fish to areas that were formerly unproductive fishing spots. The Cedar Key project, which the Gainesville Offshore Fishing Club backed, was designed for different groups to use the reef.

On September 6, 1984, Carla Anderson and Julie Stetzel began publishing the *Cedar Key Beacon*, a weekly newspaper that chronicled the town's doings. It claimed to be "the island's first locally owned and operated weekly newspaper also serving southwest Levy County."

HURRICANES

In 1985, Hurricane Elena caused extensive damage to the dock area, as well as $4 million in damage to waterways, infrastructure and property along the Florida coast. The eye of Elena came within forty-five miles of Cedar Key and caused damage there estimated at $2 million. It tore a seventy-five-foot-long hole in State Road 24, washed roads away and uprooted trees and gas tanks, but the majority of buildings withstood the storm, which pounded the city with one-hundred-mile-per-hour winds for three

days before moving on to make landfall near Carrabelle, Florida. Billy Cobb, director of emergency management in Levy County, had most people evacuate Cedar Key, although the mayor, (John) Mike Allen, did not.

The hurricane caused the postponement of the annual Fourth of July festivities for four years, but the new celebration featured a parade and lots of good food. What particularly angered many of the residents was the action of Governor Bob Graham, who visited the site soon after the hurricane passed through, but would not allow the residents to return to their homes and businesses for many hours. What also annoyed the people was that Governor Graham was accompanied by dozens of people (officials, reporters and others) who were allowed to walk all around the Big Dock area. Some of those residents who were kept out of the town or who were actually arrested for attempting to enter vowed to stay on the island during subsequent hurricanes.

It took six weeks to clean up the debris. The old Thomas stilt house—whose walkway to the shore was destroyed—was not repaired and became the most photographed landmark. Some rebuilt buildings, like the Seabreeze Restaurant, were rebuilt from the ground up with walls that could withstand 160-mile-per-hour winds.

Hurricane Elena occurred during spring tides, which enhanced the storm surge and flooded the town.

Local officials were greatly relieved when federal officials did not include the town of Cedar Key on a new list of coastal barrier sites. Those places on such a list were banned from such federal benefits as flood insurance and emergency disaster repair funds, the kind of financial help that rebuilt much of the town after Hurricane Elena; areas on the list could not participate in federal funds for building infrastructure.

Elena also caused a change of heart with regard to flood insurance. In 1983, local officials made the major decision to reject the federal government's National Flood Insurance Program, a move that most of the townspeople seemed to applaud. The philosophy of the people was, in the words of Mayor (William) Hal Hodges, "We've always believed if you have a hurricane, you take your losses and rebuild. I'm a fourth- or fifth-generation Cedar Keyan and we never worried too much about it. We never expected a government handout." The National Flood Insurance Program, which the Federal Emergency Management Agency (FEMA) created, would have forced builders to raise all new buildings, as well as buildings that were being reconstructed, so that they would be above the wave height formed by a rare but major hurricane—as high as seventeen feet above the ground in coastal areas. Flood insurance pays only for water damage, but it can be very hard to determine what damage was caused by water and what by wind. The new FEMA rules did not affect wind-damage insurance, something that many in the private sector would buy for their homes.

Local officials had a change of heart after they saw the heavy damage that Hurricane Elena caused in Cedar Key. When commissioner Frances Nesbitt made a motion to enroll in the flood insurance program, the other commissioners voted with her. Many realized that private companies did not offer flood insurance and that residents could not buy federal flood insurance unless their city or county agreed to enroll in the program and follow FEMA guidelines.

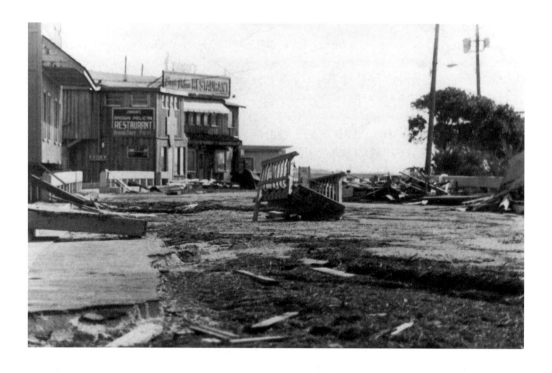

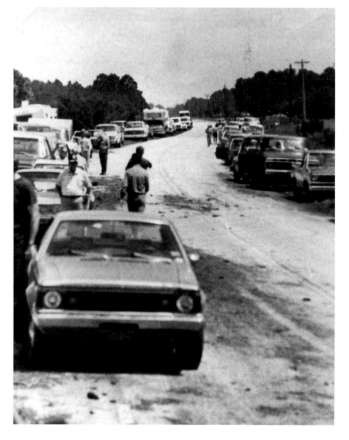

Above: Hurricane Elena in 1985 caused much damage. *Image courtesy of Lindon Lindsey.*

Left: Mandatory evacuation during a hurricane caused much bad feeling among the townspeople. *Image courtesy of Lindon Lindsey.*

In the late 1980s, workers refurbished City Hall for the first time in some twenty-five years. They renovated city offices, added a speaker's podium to the commission meeting room and added some antique pews that officials obtained from the local Methodist church (which itself had acquired new pews). The entrances to the public library and the city police department were at the rear of the building.

F.S. Fredericks, owner of Horse and Carriage Tours, built a horse-drawn carriage, bought a Clydesdale to pull the half-ton vehicle and began transporting sightseers around the city, showing them the sights.

Honors

In 1987, officials listed Cedar Key and eight thousand surrounding acres on the National Register of Historic Places, a long process that the Cedar Key Historical Society had proposed several years before. The sites included the town of Cedar Key; Sunset Point; and the nearby islands of Atsena Otie, Deadman's, Lime, North, Seahorse and Snake. Being on the register would help preserve the town without infringing on property rights. In fact, property owners could receive tax credits and government grants. Being on the register prevents some government projects from destroying the listed place. For example, if a federally funded road- or bridge-building project was planned for the Cedar Key historic district, the person or organization planning the road or bridge work would have to go through an additional step in the environmental-impact process before the work could begin. The Cedar Key Historical and Archeological District, which is the official name of the designated area, included 110 buildings in the Old Town section of Cedar Key, as well as the lighthouse and powder magazine on Seahorse Key. Properties are placed on the national register when they are considered important to the preservation of American history, architecture, archaeology, engineering and culture. Before that designation, only the Island Hotel was on the register.

People

In 1984, D. Bruce Means, an adjunct professor of ecology at Florida State University, retraced John Muir's thousand-mile walk from Kentucky to Cedar Key and was disappointed by the devastation of the original plant and animal communities of North Florida.

In 1984, military buffs reenacted the 1865 Civil War skirmish that took place where the present State Road 24 and the Number Four Bridge intersect. After a delay of over two years, the second annual reenactment took place, but it did not work out because the landowner had not mowed the high grass and bushes. The lack of mowing made it almost impossible for the soldiers to march and to see the "enemy," and bystanders could not see anything.

A number of excellent art galleries opened in town. *Image courtesy of Kevin M. McCarthy.*

Among the people who arrived in Cedar Key in the 1980s was Harriet Smith, who came from Alabama. She worked at many jobs in the town, founded and ran the Cedar Key Seabird Rescue Station and wrote *A Naturalist's Guide to Cedar Key, Florida* (1987) about nature in the area. She started the *Cedar Key Naturalist*, a twice-monthly newsletter about the outdoors, and she opened the Cedar Key Bookstore, possibly the only bookstore in Levy County at the time. She was an outspoken person who opposed the sale of lots on Atsena Otie Key by Rex Andrews, the man who had inherited the offshore island from his father, Edwin Andrews.

In 1984, the Cedar Key Oystermen's Association, Inc. was organized to preserve and upgrade the oyster industry in Cedar Key and work to solve problems associated with it. Officers were Walter Beckham, president; Doug Calvert, secretary; and Donny Beckham, treasurer. The local Cedar Key organization was meant to be a clearinghouse between the state and planters. That year the state legislature appropriated forty thousand dollars for the planting of oysters.

More and more artists moved to Cedar Key to take advantage of the surrounding scenery and creative atmosphere, or began exhibiting their art in galleries like The Gallery, run by George Sandora and attracting artists like Robbie Armistead, Ted CoConis, Claude Croney, Bill Roberts and Dohrn Zachai.

The unexplained disappearance of fisherman Ludwig "Lud" Johnson in 1989 drew the town together as his fellow fishermen, neighbors and the Coast Guard frantically searched for the city commissioner when he failed to return from a grouper-fishing trip. Divers found his sunken boat in ninety-five-foot water sixty-five miles southwest of Cedar Key, but found no sign of the man, who left behind a wife and two children.

Workers tried to raise the boat in order to try to find out what happened but were unable to do so. The city commission eventually voted to fill the vacancy left by Johnson's disappearance by appointing his wife, Aida Johnson, to fill her husband's position. Her husband's body was never found. Such were the dangers that fishermen faced in the unpredictable gulf.

The mayors of Cedar Key in the 1980s were Leif Johannesen (1979–1980), Lonnie Herald Turner (1980–1981), Jesse Quitman Hodges (1981–1982), Gary D. Haldeman (1982–1983), William Hal Hodges (1983–1984), John Michael Allen (1984–1986), Frances M. Nesbitt (1986–1987), Lucien Charles "Junior" Smith (1987–1988), Robert M. Edson (1988–1989) and Jesse Quitman Hodges (1989–1990).

1990–1999

CRIME

In 1990, law-enforcement officers arrested Rosewood businessman and attorney, Charles DeCarlo—along with David Nelson and four others from the western part of Levy County—in a huge cocaine sting operation. In what was called Operation Fishhook, the defendants were convinced that they were transporting a $52-million shipload of cocaine to Cedar Key, but the "smugglers" who convinced them about a huge pay-off were actually lawmen posing as wealthy drug dealers, and in fact most of the sacks of white powder brought to shore contained flour.

As part of his conviction, DeCarlo was sentenced to fifteen years in prison and he forfeited the Cedars Mall in Cedar Key and 126 acres of land near Shell Mound to the federal officers. The Cedars Mall was sold, with half of the proceeds (about one hundred thousand dollars) going to the sheriff's department. The Florida Department of Natural Resources took control of the 126 acres of land. Officials also sold DeCarlo's two mobile-home parks, as well as his restaurant (the Cedars Restaurant and Lounge) and airstrip in Rosewood, with the proceeds divided between the sheriff's department and the Florida Department of Law Enforcement.

VEHICLES AND BUILDINGS

In 1990, the Cedar Key Volunteer Fire Department equipment inventory doubled with the purchase of a second fire truck. It joined the department's other truck, which was twenty years old but had fewer than ten thousand miles on the odometer because it was called out an average of just once a month. Officials bought a second truck to be prepared in case of two fires at the same time. The first truck held five hundred gallons of water at a time; the second truck held one thousand gallons. Officials expected to pay off the $83,000 price tag for the new truck over seven years, partly from money that

Some of the property that the defendants forfeited was across from the marina. *Image courtesy of Kevin M. McCarthy.*

Levy County pays Cedar Key from a fire assessment fee. The firemen planned to park the new truck in a carport attached to the side of the two-bay fire department after they enlarged and enclosed the facility.

In 1992, Marcia Rogers sold the Island Hotel to Alison and Tom Sanders, who gave the buildings a thorough cleaning, rebuilt the Neptune Bar and had a restoration expert (Katrina Blumenstein) restore and preserve the painting of King Neptune. The hotel remained unique in that the rooms did not contain such distractions as televisions or telephones. The courtyard was the year-round home for Bernard Basset, the official hotel dog. At one point, a visitor, thinking the dog was a stray, picked up the animal, but later returned it to Alison after newspapers widely reported the disappearance. Chef Jahn McCumbers, who worked in the hotel kitchen for fourteen years, helped to broaden the menu to include steak, chicken and pork tenderloin.

In 1996, the Sanderses sold the hotel to Dawn Fisher and Tony Cousins, who had come to Florida from England to investigate the possibility of purchasing a hotel or motel in the St. Petersburg area. They wound up in Cedar Key and, like so many others before and after them, fell in love with the Island Hotel. They installed central heat and air in the main building and upstairs annex, which also has a restored conference room. They also completely refurbished the three bedrooms on the ground floor.

Willis Marina, run by Joy and Jimmy O'Hara, opened in Cedar Key in 1993 to offer an on-the-water source for fuel, bait, ice, drinks, boat maintenance and even the renting of boats.

In 1997, the State of Florida opened a $1.8-million building in Cedar Key near the Number Four Channel Bridge along State Road 24 for marine education, research and

Willis Marina eventually became Cedar Key Marina. *Image courtesy of Kevin M. McCarthy.*

law enforcement. The ten-thousand-square-foot facility is operated by the Florida Fish and Wildlife Conservation Commission's (FWC) Fish and Wildlife Research Institute (FWRI). FWRI scientists at the facility monitor and gather data on fisheries in the Suwannee River estuary and educate the public about the coastal environment. The location is one of seven FWRI facilities throughout Florida from which regular monthly fisheries-independent monitoring of estuarine fishes and invertebrates is conducted. FWRI scientists based at this field lab also monitor recreational- and commercial-fishery landings along the Big Bend. All the data provides valuable information to help maintain the success and health of the state's fisheries. Scientists realized that whatever flowed into the Suwannee River along its long trip from the swamps of Georgia would eventually wash into the Gulf of Mexico and therefore they had to monitor its quality and ensure that its waters remained as free from pollutants as possible.

The old Andrews tract at the southwest tip of Cedar Key, which once had the Standard Manufacturing Company, became the site of much contention between the new developer, Jeanne Morgan, who wanted to build an $8-million condominium complex there, and the federal government, which labeled the place an uninhabited barrier island and therefore one that was ineligible for federal flood insurance. The 6.6-acre condo site was part of the Coastal Barrier Resource Act of 1988, a law meant to protect barrier islands from development and safeguard the health and welfare of residents who might build there. If that designation held, then the planned Old Fenimore Mill Condominium complex would be ineligible for federal flood-insurance protection, insurance that is less expensive and less subject to cancellation than private insurance.

The name of the complex took its name from Old Fenimore Mill, a sawmill that was located there before the Fiber Factory. Local city commissioner Jesse Quitman

Hodges also pointed out that the site once housed three oil distributorships at one time or another, as well as the city light plant. The only original building still standing on the site was a warehouse for the Fiber Factory, which consisted of seven buildings. The warehouse was later leased to a crab cannery and now houses the office for Fenimore Mill Condominiums.

The issue festered for months. The site, which was near the Cedar Cove Condominium complex, was the last uninhabited section of Cedar Key. Finally, in 1998, Congress removed the eastern tip of Cedar Key from the coastal barrier resources program, making condominium owners eligible for federal flood insurance. The project finally opened with twenty-four condominiums to the northeast of the City Park. The bottom floors of the units are twenty-three feet off the ground in order to meet Federal Emergency Management Agency requirements.

In 1991, officials instituted a policy of having boaters using the launching ramp in Cedar Key voluntarily pay a fee of one dollar into a metal tube each time they launched a boat. They did this in order to recoup part of the $750,000 in state funds they had spent in the past year to improve the boat basin and boat launch. That project dredged a canal to the boat basin to allow five feet of clearance at low tide, a figure that allowed big boats to use the basin. Also, workers built twenty-six new slips, eighteen of which were leased to boaters. Officials estimated that the honor system was apparently working, since about half of the people launching boats paid the fee. As many as two hundred boats were launched on a Saturday or Sunday in good weather. As time went on and hurricanes took their toll, the fee increased to five dollars in 1994 and then ten dollars in 2002 in order to make the marina self-sufficient for maintenance and repairs. City officials also added twenty-four boat slips to the eighteen already at the City Marina. Half of those would be available for a rental fee of fifty dollars a month on a first-come basis.

George T. Lewis Airport

The George T. Lewis Airport near Cedar Key occupied much time at local town meetings as officials struggled to accommodate the airport to regulations. A report from the early 1990s stated that the airport handled about 2 percent of the region's total operations and provided storage for nearly 2 percent of the region's based aircraft. Over 90 percent of the airport's operations were tourist related. Total operations, which were 4,972 in 1990, were expected to grow to 6,415 in 2010. One writer estimated that, if each plane held two people in it and each spent one hundred dollars a day in Cedar Key, if even for one day, that would mean that the airport generated almost a million dollars a year for Cedar Key businesses.

The county maintained the airport by mowing the grass, maintaining the paved airstrip and coordinating improvement projects, like the runway lighting that workers installed in 1993, eight years after that was recommended in a plan for the area. The airport has no control tower, which puts the burden on pilots to determine when it is safe to land and take off without interfering with other aircraft. On many, if not most, weekends, as many

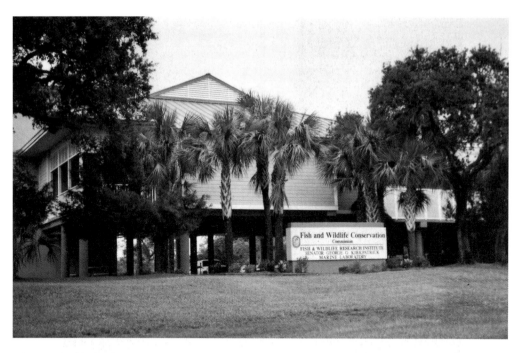

The new building of the Florida Fish and Wildlife Conservation Commission houses a number of scientists who work in the nearby waters. *Image courtesy of Kevin M. McCarthy.*

The owner of the Old Fenimore Mill Condominium complex had many hurdles to overcome before building the beautiful project. *Image courtesy of Kevin M. McCarthy.*

Boaters using the launch facilities at the marina voluntarily pay a fee into a metal tube. *Image courtesy of Kevin M. McCarthy.*

as one hundred aircraft will use the airstrip, with another fifty or so planes on the ground. A half dozen residents who live near the airstrip own planes that they keep next to their homes or at the county-owned and maintained tie-down area near the airstrip.

VETERANS' MEMORIAL

In July 1994, officials dedicated a veterans' memorial in front of City Hall to honor all the local soldiers who had served in World War II, the Korean Conflict and the Vietnam War. Lloyd Stephens, himself a veteran and a resident in the town since 1922, did much of the name collecting and fund raising. Although most survived the wars in which they served, a star beside a name commemorates those who lost their lives.

The local Veterans' of Foreign Wars post, 9528, held meetings throughout the year.

BAN ON NET FISHING

In the 1994 general election, voters throughout the state overwhelmingly voted for a net ban, which went into effect on July 1, 1995, and was meant to stop the depletion of fish stocks in the Gulf of Mexico. Some argued that the wording of the net ban was so confusing that people were not sure what they were voting for or against.

The constitutional amendment banned gill nets, entangling nets and nets larger than five hundred square feet nine miles into the Gulf of Mexico and three miles into the Atlantic Ocean. The state bought the fishermen's nets, although at a reduced rate, and shipped them to a recycling plant in Tampa. Fishermen sold the lead weights to battery manufacturers. Officials estimated that the net ban put twenty-five local families out of business and affected many more people on the island who were involved with the fishermen.

Not only did the ban force fishermen into other fields, but even land-based establishments like the Cedar Key Fish and Oyster Co., the last fish house on the island, closed its doors for good after twenty-four years of operation. The net ban caused much hardship in Cedar Key and other Florida towns along each coast, forcing long-time fishermen to learn new trades. On July 4, 1995, city officials dedicated a memorial in front of City Hall that honored the net fishermen who lost their jobs because of the net ban. One result of the net ban was that all the mullet served at the fall seafood festival, over four thousand pounds, had to be caught by cast nets—small nets thrown over the side of boats by hand—a process that took three weeks to complete instead of the days required when the larger nets had been used.

OYSTER AND CLAM FARMING

Between 1989 and 1991, state and federal officials temporarily closed many of the most productive wild-oyster beds in the Suwannee Sound because of concerns about

The veterans' memorial near City Hall honors the many local men and women who have served our country in the military. *Image courtesy of Kevin M. McCarthy.*

bacteriological pollution. For those oystermen who lost their livelihood because of those closures, Project OCEAN (Oyster and Clam Educational Aquaculture Network) in 1991 taught them to raise clams and oysters, using offshore state aquaculture leases, as part of the federally funded aquaculture program to retrain local oyster harvesters and seafood workers who could no longer make a living from depleted or polluted wild-oyster beds. About two hundred Levy and Dixie county fishermen signed on for two years of training by personnel from the Harbor Branch Oceanographic Institution, and 138 successfully completed the program. The graduates of the program were given two 2-acre underwater leases: half for clams and half for oysters.

The clam farmers lease underwater plots from the state and then buy tiny seed clams from a hatchery, where they were bred under controlled conditions. Then the clammers plant them in rows as a farmer would plant a crop like corn. The clammers plant the clams in mesh nursery bags, each bag containing ten thousand seed clams, staked to the bottom of the sea bed. When the clams grow to twelve millimeters in size, they are transferred to what are called "grow-out bags," at about one thousand per bag. Workers cover the bags with chicken wire to keep away predator fish, like the black drum, that eat clams. Then the clammers return the clams to the water, where they will remain for a year until they are ready for harvesting. The clammers usually plant the clams monthly and harvest others on a weekly basis. The clammers sort and market the clams according to size—thickness, not diameter.

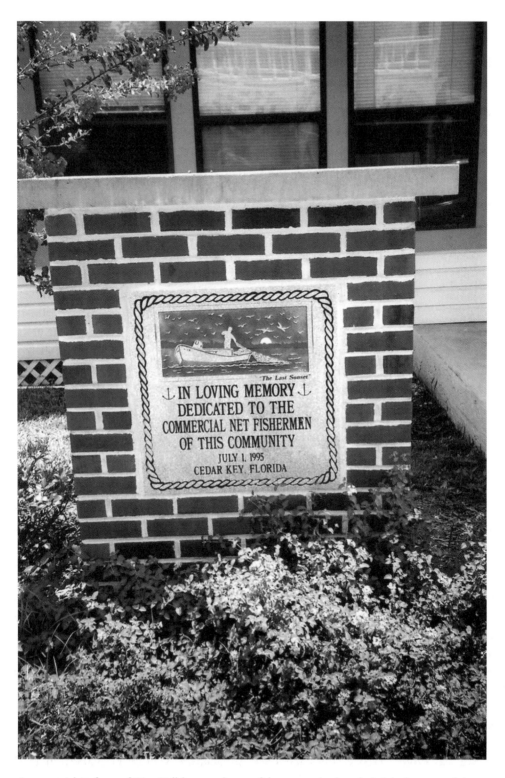

A memorial in front of City Hall honors the net fishermen who lost their jobs because of the net ban. *Image courtesy of Kevin M. McCarthy.*

The clammers can harvest about one million clams per acre, possibly more, depending on various conditions. A half-million clams were selling for about forty thousand dollars at the beginning of the program. Restaurant owners and seafood eaters prefer such farm-raised seafood because scientists can certify that the clams are safer from impurities. Also, the clams come in uniform sizes, which restaurants prefer. Cedar Key waters are ideal for clam farming because they are much less polluted than other areas and have a shorter harvest time because of the warmer water and amount of food or algae available.

A 1996 state law categorized clam farmers as part of the agriculture work force regulated by the Florida Department of Agriculture and Consumer Services (DACS).

In 1997 and 1998, the flood waters spawned by El Niño diluted the salt content of the gulf off Cedar Key and killed millions of farm clams, setting the industry back and not allowing it to double its production, as had been expected. That meant that clam farmers joined tropical fish farmers, gator ranchers, aquatic plant growers and other aquaculturists and were eligible for the same benefits as land farmers, including disaster assistance if a hurricane ruins their crop, as long as they signed up for the non-insured crop disaster-assistance program. Under the new state law shellfish farmers no longer had to identify themselves or their product with a saltwater fishing license but were required to have an aquaculture certificate.

By 1998, more than three hundred people were growing clams on about 1,400 leased acres in gulf waters off Levy and Dixie counties, bringing in over $7 million of income to the area. The production of cultured clams went from zero in 1991 to 50 million clams in 1997. It was not easy work, and the clammers had to face the problems of expanding markets and ensuring clean waters.

Within a few years, those growers of farm-raised clams were producing more than 70 percent of the state's total clam output. The business became so successful that the U.S. Coast Guard made arrests of clam rustlers, criminals who went out at night and stole clams from the different beds. A private security company offered surveillance of the clam leases in order to prevent such thefts.

Among the new facilities built in the nineties to accommodate the growing numbers of clam fishermen was Nature Coast Industries, directed by Bill Delaino, at the Number Three Channel Bridge. That company constructed a building for processing and packaging marketable clams, as well as nursing them to grow-out size. The company also grew clams on ocean-bottom leases in the gulf. Nearby, Cedar Key Aquaculture Farms, Inc., under the direction of Dan Solano, developed a sophisticated hatchery that produced 70 million clam seeds a year, of which 80 percent would be sold to local farmers. The rest were used on the company's clam leases in the gulf. Microbiologist Amy Picchi advised her staff on how to raise clams from the microscopic egg size to nursery size.

Another federal program meant to help those fishermen put out of business by the net ban was Project WAVE (Withlacoochee Aquaculture Venture Education) in 1995. In the one-year-long program, Harbor Branch Oceanographic Institution staff taught students from Levy, Dixie, Citrus and Taylor counties to grow clams in field nurseries

and underwater areas suitable for clams. The graduates of the program were given two-acre underwater clam leases. The project also taught fishermen how to operate land-based shellfish nurseries, for example, how to grow clams to a suitable size that can then be transplanted to leases in the Gulf of Mexico.

University of Florida Aquaculture Extension Agent Leslie Sturmer (later Sturmer-Taiani) won a fifty-thousand-dollar grant for development of a community land-based clam nursery in Dixie County to be located in Horseshoe Beach. That nursery provided facilities for a dozen or so clam farmers who did not have access to waterfront property.

HONORS

In 1993 Governor Lawton Chiles named Cedar Key Florida's Outstanding Rural Community of the Year.

PEOPLE

In 1990, fourteen-year-old Joanne Hathcox became the first girl to play on the Cedar Key boys' baseball team. She had begun her career in Chiefland Youth League Baseball when she played first string on the Cedar Key team for three years. At that time two other girls were playing in the same league. Joanne would have preferred to play softball, but Cedar Key High School did not field a team.

Lilly Wilkerson became the first woman elected to the County Commission (early 1990s) and the first to chair the Levy County Commission (1994).

Beginning in the mid-1990s, a group of local writers, Cedar Key Poets, began meeting and from time to time would publish their work, such as *Cedar Key Poets 2006*, which helped fund projects by the Friends of the Library.

In 1997, Mike Raftis, the publisher of the town's fine weekly newspaper (the *Cedar Key Beacon*) opened up a used-car lot in Cedar Key, the first time that cars were sold in the island city since the 1920s.

In 1999, the Cedar Key Eagles Aerie 4194, a club that began locally in 1988, bought a house at the corner of B and Third Streets that William Wallace McLeod (Little Uncle Will) had built in 1910 as a single-family dwelling. The State Eagles Aerie recognized the Cedar Key group as Florida's second largest contributor to Eagle and local charities in 1999. The Cedar Key Eagles provide medical equipment for those in need, have supported the local school by organizing fund-raising events for sports teams and playground equipment and allow the local children to buy something for their parents for little or nothing. One annual fundraiser in the spring is a Spam cook-off, with the creative cooks on the island coming up with various concoctions like Spam-stuffed mushrooms, Spam cheesecake and Spam ice cream.

The feminine counterpart of the Eagles, the Cedar Key Fraternal Order of Eagles Auxiliary 4194, had a Christmas in July Festival to raise money for their projects, like

The clubhouse of the Eagles is one block away from the main street. *Image courtesy of Kevin M. McCarthy.*

supporting the Sunshine Foundation Dream Village in Loughman, Florida. Founded in 1976, the Sunshine Foundation granted twenty-four thousand wishes to chronically and terminally ill children ages three to twenty-one. The Cedar Key Eagles Auxiliary held a charity dinner on the fourth Saturday of each month at their clubhouse.

THE BIG DOCK

In 1998, sailors manning the training ship *Resilience* docked it at the end of the Big Dock in order to allow youngsters in the U.S. Naval Sea Cadets program to use it for training. The former Naval Academy training ship, built in 1958 to teach Naval Academy midshipmen the fundamentals of seamanship, was redesigned in the 1980s to be a part of the fleet of highly maneuverable navy minesweepers. It was then donated in 1995 to the Henry and Rilla White Foundation, a social service agency in Levy County that made the ship available to the Sea Cadets program. The Naval Sea Cadet Corps is a nonprofit organization supported by the U.S. Navy and Coast Guard and open to youngsters from the ages of thirteen to eighteen. The goal of the Sea Cadets is to promote interest in naval careers, train young people in seamanship and provide leadership experience. Lieutenant Commander Joe Land was responsible for developing the Sea Cadet program in Levy County.

In 1999, the Cedar Key-based program suffered a setback when its training ship, *Resilience*, was sold. The group then found another ship whose owners donated it to them,

but it was in Connecticut. The director and four cadets flew to Connecticut to take ownership of the vessel, the thirty-three-foot cabin cruiser *Larissa*, and sail it down south, but it developed problems off New Jersey and had to be taken in there. They eventually got the ship to Cedar Key, renamed it the *Trident* and began using it for training.

At the beginning of the decade, the Cedar Key Nature Circle funded a project to help make the Marina Basin north of the Big Dock safer for seabirds by putting the electric wires that had crossed the Number One Bridge out of sight. Workers also put all streetlight wires on the opposite end of the basin out of sight. To protect the birds from the power poles around town, workers put extender arms on the poles, positioning the nests farther away from hot wires.

ANDREWS HOME MOVE

In 1995, house-movers picked up the historic Andrews home from 39 Second Street and moved it about a half mile from where it had been built in 1910 near City Park to a location behind the Cedar Key Historical Society Museum on State Road 24. The surviving members of the family that grew up in the house, Dr. John Andrews (a Gainesville physician) and Dan Andrews Jr. (a retired accountant living in Ocala) donated the house to the historical society after the death of their mother, Cora Tooke Andrews, in 1992. Mrs. Andrews had been born and raised on nearby Scale Key and then lived in the house that her late husband had built before she moved to Gainesville in 1984.

The society, of which Dr. Andrews was an officer and strong supporter, restored the home and used it to exhibit its extensive collection of material from the Standard Manufacturing Company, including an exhibit about the way that brushes are made.

The historical society museum is in the old Lutterloh Building at the corner of Main Street and State Road 24. Alison Sanders of the Island Hotel helped obtain a grant to restore the Andrews House in 1995. Polly Pillsbury raised the money to purchase the first museum building from Gertrude Teas in 1978. There was no grant involved in that. Elizabeth Ehrbar created the exhibits in the Andrews House with the help of Peggy Rix. The large upstairs living room in the Andrews House is used for meetings, weddings and parties. For a small price, visitors can buy a brochure entitled "Historic Old Cedar Key: A Walking Tour" at the museum and take a leisurely stroll along the streets to see three dozen of the important structures still existing in the city.

INDIAN BURIAL MOUND MEMORIAL GARDEN

In 1998, members of the Cedar Key Garden Club, the Historical Society, Lions Club and Woman's Club dedicated the Indian Burial Mound Memorial Garden next to the Lions' clubhouse on the northwest corner of Sixth and F Streets in Cedar Key. The garden memorialized the Native Americans buried at the site hundreds of years ago, as well as some black residents interred there in the 1800s.

When the Lions' clubhouse was being constructed there about ten years before, no one knew that the ordinary-looking hill had once served such a solemn function. Bob Edson, the mayor and head of the police department at the time, called on the services of a forensic scientist, who identified the remains of an African American at the site. Scientists were able to determine whether the gravesites were those of Native Americans (who buried their dead facing west, toward the gulf, the source of their livelihood and a powerful force in their lives) or African American Christians (who buried their dead toward the east).

The Lions then built their clubhouse on the high hill, but did not disturb the grave area. Workers reburied the bones of the African American there, filled in the excavated area and built a retaining wall to protect it from erosion and other damage. The garden is on top of the walled mound with a selection of plants chosen by Garden Club member Marion Wilson, including coontie (a native plant sometimes called "Indian corn"), jasmine, nandina and Texas sage, all of which are drought resistant and easy to maintain. The student Garden Club at Cedar Key High School planted liriope around the base of the retaining wall to form a decorative border that set the garden off from the parking lot.

In 1999, the Garden Club received a $5,700 grant from the Environmental Protection Agency for the eradication of a non-native species in Cedar Key: the Brazilian pepper tree (*Schinus terebinthifolius*), which is a fast-growing, aggressive, invasive, non-indigenous plant that invades aquatic and terrestrial habitats and crowds out desirable native trees and shrubs.

SHELL MOUND ARCHAEOLOGICAL SITE

The Shell Mound Archaeological Site on Southwest 78th Place off County Road 347, which is about six miles east of Cedar Key, attracts some fifty thousand visitors a year to fish, swim, bird watch or walk through the pristine area. In 1986, the U.S. Fish and Wildlife Service had bought 5.4 acres of land from E.T. Usher at the end of Shell Mound Road as an addition to the Lower Suwannee National Wildlife Refuge. In 1997, officials built a three-hundred-foot-long boardwalk and named it after longtime volunteer Al Georges of Cedar Key. The boardwalk gave visitors access to a popular fishing hole and overlooks the estuary that surrounds Shell Mound. The site has been part of the Lower Suwannee National Wildlife Refuge since 1981. Ken Litzenberger was the manager of the refuge.

ATSENA OTIE KEY

When the owner of Atsena Otie Key, a company named Depot Key Joint Venture, which Rex Andrews had formed, revealed plans in the 1980s to build more than thirty luxury homes on the coastal barrier island, with prices for lots ranging from thirty-five thousand

Above: The Andrews House is now behind the Cedar Key Historical Society Museum. *Image courtesy of Kevin M. McCarthy.*

Left: The long dock at Shell Mound honors a longtime volunteer. *Image courtesy of Kevin M. McCarthy.*

to sixty thousand dollars, many people banded together to put a stop to that and tried to buy the island before development took place. Each home was to have its own water well and would use a septic system for waste disposal. No automobiles, other than golf carts, would be allowed on the island, and owners could access the island only by boat. A common area might contain a swimming pool and tennis courts. The company sought permission to build two underwater power cables from Cedar Key to the island.

It would have been expensive to live on the offshore island. The owners of the lots would have had to pay to transport all the building materials for their houses across the half-mile of water from Cedar Key. Workers would then have to comply with the regulations of the owners' covenant and with the regulations of the Federal Emergency Management Act; according to the former, homes would need to be built in an older style that could withstand hurricanes.

Because hurricanes could hit the island, as they have done in the past, houses there would have to be built at least nineteen feet above sea level to protect them against storm surges; and the houses would have to be able to withstand winds up to 120 miles per hour. For years, the barrier island has blunted any hurricanes headed directly for Cedar Key and the mainland, but the island has also suffered from those storms.

Homeowners would have had to install their own well or cistern and septic tanks. Property owners would be required to recycle and mulch as much of their trash as possible. Garbage would probably be deposited in one place for pickup by crews from the mainland. The city of Cedar Key's garbage facility, which was operating at 5,250 pounds a day in the early 1990s, had a capacity of handling 20,800 pounds a day. The property owners of Atsena Otie, like those elsewhere in the county, would be required to pay special assessments for landfill, ambulance and fire services, but the level of service for the island might not be the same as for those on more accessible land sites. The owners of the island were also allowed to build a pier where boats could tie up.

Many people in Cedar Key realized that they would be the ones who would have to provide boat- and car-storage facilities, more parking lots for the residents of the offshore island, dockside garbage pickup and disposal services, disaster preparedness, an escape route for the residents of the island in time of hurricanes, even fire protection for the homes, schooling, emergency medical aid and police protection.

After much debate about what should happen to Atsena Otie Key, its owner sold it to the Suwannee River Water Management District, which entered an agreement with the U.S. Fish and Wildlife Service to have the island become part of the Cedar Keys and Lower Suwannee National Wildlife Refuges (NWR). The price of the island: $3.1 million.

The island is open for public use, but the same rules apply there as on the other lands under the NWR. Firearms, fires, alcoholic beverages and pets are not allowed. Visitors can swim, hike, fish and observe nature, but may not camp on the island. The Cedar Key Historical Society agreed to work on obtaining grants for developing interpretive walks and putting up educational kiosks on the island. The island still has a cistern and a cemetery and remnants of a windmill tower.

Part of the purpose of buying the island was to preserve the waters around the island for fishing and clamming. The island might also become part of eco-tourism, which

Atsena Otie has a long dock, allowing boaters to tie up while they go ashore for a visit. *Image courtesy of Kevin M. McCarthy.*

The outdoor theater at the school is the site of ceremonies and plays. *Image courtesy of Kevin M. McCarthy.*

The boat at the state museum has probably been through many storms and hurricanes. *Image courtesy of Kevin M. McCarthy.*

emphasizes preservation and conservation of wilderness areas and pristine natural environments. The limitations on the number of visitors will ensure that preservation. Signs remind visitors to take away all of their trash, and a self-composting portable toilet near the dock can accommodate visitors' needs and reduce the environmental impact of human waste on the offshore clam lease sites. Groups like the Friends of Atsena Otie can do much in preserving the island.

HURRICANES AND TROPICAL STORMS OF THE 1990s

Some of the hurricanes and tropical storms that hit Cedar Key in the 1990s were Marco (1990), Harvey (1992), the so-called Storm of the Century (1993), Alison and Opal (1995), Josephine (1996), Earl (1998) and Irene (1999, which postponed the annual seafood festival to the following weekend). The police would usually close down State Road 24 to incoming traffic during the storms. The fact that only one road leads into and out of Cedar Key makes it easy for law-enforcement officials to control traffic, but it hampers residents who want to leave or enter by another way. Local officials sometimes opened up the Lions Club in Cedar Key as a shelter when a storm surge was expected.

After the 1993 Storm of the Century—also called the No-Name Hurricane because its arrival before hurricane season had people unprepared—and damage to the Big Dock from a large boat, officials closed the dock for repairs until they were finished by Labor Day of that year. The 1993 Storm of the Century caused damage estimated at $45 million to the coastal areas. What was surprising was how little damage that storm did to offshore clam beds, which are usually very susceptible to severe storms that can stir up the sea bottom, bury the clams and kill them. Officials have warned the residents that a category four or category five hurricane like Andrew or Katrina can tear up State Road 24 and totally isolate Cedar Key. They stress that evacuation is much safer than riding out a hurricane.

In 1997, meteorologist Walter Zileski of the National Weather Service told a group of people in Cedar Key that the city, on average, experiences a category one hurricane every nine years, but that the location of the city (on an island and in an area with the most shallow continental shelf on the entire U.S. coastline) is not good for surviving hurricanes. For example, because of the shallow continental shelf, it is easy for the water to pile up. If a category four hurricane (a storm with winds of 131 to 155 miles per hour) came in from the southwest, Cedar Key could experience a storm surge up to twenty feet and waves of six to nine feet on top of that.

Toward the end of the nineties, an event called the Annual Native Cedar Key Families Reunion brought together longtime families that grew up in the area and either stayed there or moved away for different reasons. At first referred to as the Old Timers' Dinner, the event enabled those attending to share photographs and reminisce about growing up in the area. Mack McCain started it, and it takes place each March on a Saturday afternoon. It gives old-time Cedar Key people a chance to see each other, reminisce and eat some good food, like mullet and swamp cabbage.

The mayors of Cedar Key in the 1990s were Jesse Quitman Hodges (1989–1990), Helen E. Johannesen (1990–1991), Walter Melvin Beckham (1991–1992), Robert M. Edson (1992–1995), Helen E. Johannesen (1995–1996), Michael W. Davis (1996–1998) and Gary W. Hathcox (1998–2000).

THE 1990s

In 1990, Levy County joined with other coastal counties in Florida to form the Nature Coast Coalition, geared to attracting visitors who wanted to experience nature instead of golf courses and high-rises. As the people of Cedar Key entered the new millennium, they were proud of how they had maintained the charm of their island city but were wary of outside forces building new structures and changing the city in minor ways. The weekends continued to be busy with boaters and visitors, but the rest of the week remained relatively peaceful.

The 1990s were difficult for those fishermen who lost their livelihood when the net ban took effect and were difficult for local homeowners who saw their taxes rise dramatically. Many of the out-of-work fishermen resorted to aquaculture and did well, but resentment remained for those unseen voters who deprived the fishermen of their livelihood. The property appraiser, Francis Akins, increased property appraisals an average of 62 percent (and in some cases 300 percent) in 1994 alone because of the dramatic increase

The dock is a good place for some quiet fishing. *Image courtesy of Kevin M. McCarthy.*

in real estate prices on the island over the past several years. The lawsuits that resulted tied up the matter in the courts for some time.

Most of the fishermen who were put out of business by the net ban survived, many of them switching careers to the harvesting of clams or oysters, but it was another example of how close the town came to economic disaster, something it has experienced several times in its history.

2000-2007

Stars-n-Parks

Beginning in February 2001, astronomers gathered in places around the country, including Cedar Key, for a weeklong event of stargazing. The dark, clear skies and mild temperatures made Cedar Key a particular favorite for such events. The Florida Park Service helped sponsor the Cedar Key Star Party with public education activities at the local state parks. The clear, dry air helped astronomers in their solar observations, which they could do with special lens filters to keep the light of the sun from burning their eyes.

Churches

Cedar Key First Baptist Church had a new pastor, Mike Shelby, beginning in 2006.

In the early 2000s, the congregation at Cedar Key United Methodist Church installed eleven stained-glass windows designed by local high school students and handcrafted by a local artist, Don Joyce, owner of Haven Isle Gift & Glass. Each window depicts a biblical scene on the top panel and a Cedar Key scene—hurricanes, the seafood and arts festivals and the monthly church suppers—on the bottom panel. The pastors of the Cedar Key United Methodist Church in the 2000s were Jim Campbell (1998–2003), David Woerner and Debra Halcomb (2003–2004), Debra Halcomb and James Howes (2004–2006) and Clark Reichert (2006–).

Buildings

The Island Hotel Bed & Breakfast changed hands several times in the 2000s. Marylou and Bill Stewart bought it in 2001, but in October 2002 they fired all the staff, boarded up the building and headed back to Texas for reasons that are still unknown.

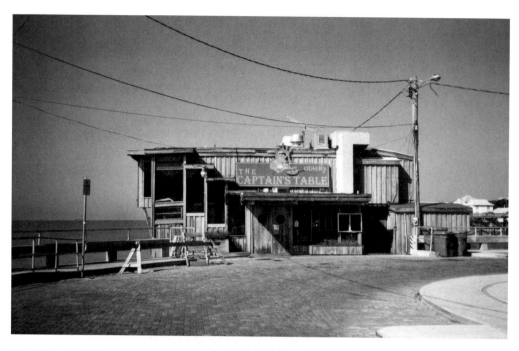

The Captain's Table Restaurant has been at the same place on the dock for many years. *Image courtesy of Kevin M. McCarthy.*

In November the court appointed Dawn and Tony Cousins to take over the hotel as receivers. In January 2004, they sold it to Andy Bair and his wife, Stanley, from Atlanta. In that decade, the house was named to the National Register of Historic Buildings (2001) and to the list of Florida Heritage historical sites (2002).

In 2004, officials named the large building on State Road 24 that had opened in 1997 the Senator George G. Kirkpatrick Marine Laboratory Building in honor of the late senator, an avid fisherman who supported experimental programs that led to the development of clam farming off Levy and Dixie counties. The laboratory houses personnel from the FWC Division of Marine Fisheries Management and other agencies. Personnel from the Department of Agriculture and Consumer Services' Division of Aquaculture monitor water quality near Big Bend clam leases and oyster-harvesting areas to ensure that shellfish are not contaminated by factors such as elevated bacterial levels. They also inspect shellfish-processing plants throughout the area and enforce shellfish-harvesting laws on the water. Personnel from the University of Florida's Shellfish Aquaculture Extension Program assist clammers by providing educational, technical and organizational support for the clam-farming industry.

In 2004, officials dedicated the new public library building. The building was the former Schlemmer Rooming House, which was more than one hundred years old and which had housed the Cedar Key Volunteer Fire Department. The renovation of the building, which took more than three years, was funded by volunteers, the city, the Division of Historic Preservation and the Felburn Foundation.

The Cedar Key United Methodist Church depicts some of the history of the town through the church windows. *Image courtesy of Kevin M. McCarthy.*

The town offers many different kinds of accommodations, including several right on the water. *Image courtesy of Kevin M. McCarthy.*

The library is now in the former Schlemmer Rooming House. *Image courtesy of Kevin M. McCarthy.*

LOCAL CONSTRUCTION

In 2004, Rob Crane, of the Nature Coast Conservancy, opened the Cedar Key Railroad Trestle Nature Trail along the path that the train used to take from Fernandina to Cedar Key from 1861 to 1932. A kiosk at the site tells the story of the railroad trestle and its importance to the economy of the area. At the end of the trail visitors can see the remains of the trestle leading into Cedar Key from the mangrove bushes at the end of a raised train embankment.

In 2006, the city of Cedar Key acquired the clubhouse of the Lions Club and planned to convert it into a community center.

CEDAR KEY HIGH SCHOOL

In February 2002, fire destroyed one of the structures at Cedar Key High School, a facility that served students in all grades who lived in the area. The community was devastated by the loss, but resolved to build another building as quickly as possible. Within four weeks, principal Dan Faircloth had portable classrooms on the site, as well as offices. In the late fall of 2003 workers had completed the new structure, which was paid for with insurance money, contributions by many and by a generous $250,000 donation from Pam and Doug Bishop, who were honored with a plaque that dedicated the new auditorium to them. Doug Bishop was a 1944 graduate of Cedar Key High School who had gone on to do well in business. The school has grades from pre-kindergarten through twelfth, and the students consistently rank above the state average on statewide tests. The new school building resembles the original 1915 building.

CEDAR KEY STATE MUSEUM

In 2003, the nonprofit St. Clair Whitman Citizen Support Organization opened the St. Clair Whitman House on the grounds of the Cedar Key State Museum after restoring it. Among the fundraisers for the house was the selling and laying of personalized bricks in front of the house.

SEAHORSE KEY MARINE LABORATORY (SHKML)

The marine biology lab, established by the University of Florida in 1953, continued to function, taking advantage of its strategic location (coastal, subtropical and with access to pristine coastline) to conduct much research about the Gulf of Mexico. It attracted national and international scientists, including those from Brazil, Israel, Japan and Taiwan. The SHKML supported over three dozen different courses representing a broad array of disciplines, including botany, ecosystems ecology, engineering, environmental

At the end of the Railroad Trestle Nature Trail visitors can see the remains of the trestle leading from the mangrove bushes. *Image courtesy of Kevin M. McCarthy.*

Cedar Key High School has been the center of many activities in the community. *Image courtesy of Kevin M. McCarthy.*

The state museum has an old fire-fighting hose. *Image courtesy of Kevin M. McCarthy.*

chemistry, oceanography, soil sciences, wildlife ecology and conservation and zoology. The lab supported dozens of research projects (graduate, faculty and postdoctoral) and numerous undergraduate training projects. In just the last five years, researchers working there produced one book, twenty-eight journal articles, five doctoral theses, five masters theses, ten undergraduate theses and sixty-three abstracts or presentations based on work at the lab that can be identified related to work in connection with the SHKML. Scientists there won more than one million dollars in grants and fellowships in those five years. The University of Florida's research vessel R/V *Discovery* plied the waters of the gulf as part of those projects. The university spent more than two hundred thousand dollars to rebuild the seawall and docking at Seahorse Key.

CLAMS

The importance of raising clams to the Cedar Key economy is clear from the welcome sign to the town, "Welcome to Cedar Key: Producer of USA's Farm Raised Clams."

In 2000, the federal government approved, for the first time, a pilot program providing subsidized crop insurance for those farming clams in the Florida counties of Brevard, Dixie, Indian River and Levy. That meant that clam farmers could insure their clams against losses from natural disasters like hurricanes, storm surges and drops in water salinity.

The federal government recognized that clam aquaculture is farming, just like growing crops on land. At that time, the Cedar Key area had forty-five land-based clam nurseries, over two hundred clam farmers and thirty shellfish distributors. Plus there were boat builders, seamstresses of clam bags and manufacturers of clam farming equipment in the area, all of which explained why 75 percent of the one hundred million clams raised in Florida were grown off the coast of Cedar Key and Dixie County.

In 2003, the Cedar Key Aquaculture Association (CKAA) began holding an annual Clamerica celebration at City Park around the Fourth of July, when around ten thousand clam lovers could savor different clam recipes, as well as enjoy a parade, live music and fireworks. By 2005, the Cedar Key area had over two hundred clam farms, which produced one hundred million clams every year and earned ten million dollars, making it the number-one area in the nation in the field.

A signboard near the Island Jiffy store, at the intersection of State Road 24 and Whiddon Avenue, has news of the Aquaculture Association, which in 2007 was the largest association in Florida representing clam farmers.

PEOPLE

In 2001, a local conservation group began. They called themselves Friends and Volunteers of Refuges (FAVORS). The volunteers who work with the group focus on preserving the habitat and protecting the many animals in the area.

The welcome sign to the town indicates how important aquaculture is to the community.
Image courtesy of Kevin M. McCarthy.

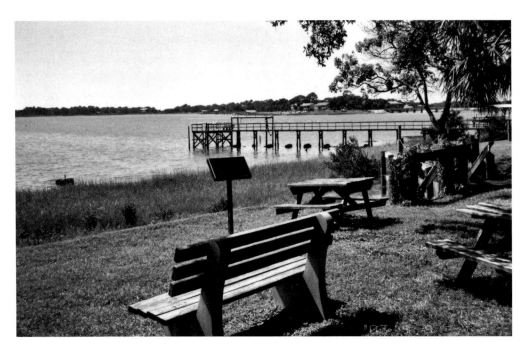

The pocket park at the end of Sixth Street honors Dorothy Tyson. *Image courtesy of Kevin M.*

In 2003, Brian Buesing, who graduated from Cedar Key High School in 2000, was killed in the war in Iraq, one of nine U.S. marines killed in an ambush and the first Levy County soldier to die in the war. He had joined the Marines one month after he graduated from high school.

Several local notables died during the first half of the decade, including Polly Pillsbury (died in 2000), who had helped establish the Cedar Key Historical Society and did many paintings in the area; Mike Raftis (died in 2004), the owner, publisher and editor of *Cedar Key Beacon* and owner of Salty's Oyster Bar & Pizzeria.

In 2005, Cedar Key lost two of its leaders at the age of ninety-one: Jesse Quitman Hodges and W. Randolph Hodges. For all but one year between 1962 and 2003, Jesse Quitman Hodges was either mayor (for eight years) or city commissioner (for thirty-one years) in Cedar Key. Known as J.Q., he had owned Hodges Marine and Supplies, worked as a boat captain and volunteered as a firefighter, a fact that convinced local authorities to dedicate a new firehouse in his honor. This new facility replaced an older building that became a library.

On November 29, 2005, Cedar Key lost another important leader, W. Randolph Hodges. The third-generation Floridian had represented his town and district well over the years. He had a daughter (Nancy Duden of Cedar Key), two sons (Hal and Gene Hodges, both of Cedar Key), an aunt (Lucile Rogers of Cedar Key), six grandchildren and ten great-grandchildren.

In 2006, Wil and Sarah Reding retraced the thousand-mile trek that environmentalist John Muir made in 1867. They noted that, while much has changed in the 140 years

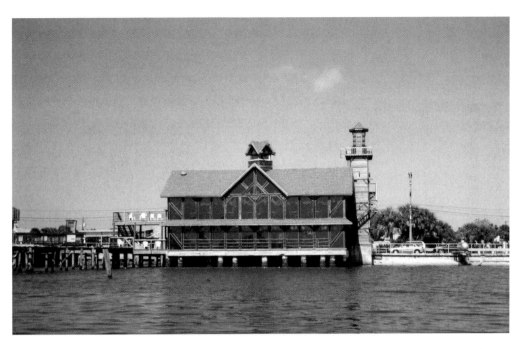

Seabreeze Restaurant is another fine restaurant near the water. *Image courtesy of Kevin M. McCarthy.*

since Muir's trip, the quiet expanses between towns are similar to what the nineteenth-century walker described.

Two local women were honored with pocket parks: Doris Delaino with the park at the west end of Fifth Street at Goose Cove and Dorothy Tyson with the park at the west end of Sixth Street. Plaques at each site note some of the accomplishments of both women. A long-established ordinance in the city provides that all city streets go to the water. The small parks established at the sites enable visitors to see the spectacular sunsets over the gulf. The late Dorothy Tyson is also memorialized with a garden at the entrance to the historical Andrews House at the Cedar Key Historical Museum. She promoted such ideas as having pocket parks at the gulf side dead end of streets, providing trash cans for recycled material and raising funds for the tennis program and courts at the local high school.

The mayors of Cedar Key in the first part of the 2000s were Gary W. Hathcox (1998–2000), Heath Michael Davis (2000–2002), Roy T. Sills (2002–2003), Kenneth Daniels (2003–2005) and Paul Oliver (2005–).

ADDITIONS

In May 2004, editors James B. Hoy and Maureen Landress began publishing a print edition of *Cedar Key News*, a bi-weekly free newspaper distributed throughout the town that had been online since May 2002. Its nonprofit membership corporation had been

The gnarled tree trunks and seashells on Atsena Otie beach are not far from the Cedar Key dock. *Image courtesy of Kevin M. McCarthy.*

publishing local news online at www.cedarkeynews.com for more than two years. In December 2003, the corporation agreed to publish and archive the minutes of the Cedar Key City Commission meetings and also published commission agendas and reports of the meetings. Local librarian Molly Jubitz later joined the staff as a layout and design person; there have been about thirty contributors of articles over the years. Each bi-weekly run of the newspaper had a press run of 1,650 copies, and the online version averaged over one thousand visits a day, an indication that people around the world are interested in Cedar Key. The masthead has each letter of the newspaper title in a signal flag.

HURRICANES AND TROPICAL STORMS

Among the hurricanes and tropical storms that hit or affected Cedar Key in the 2000s were Gordon (2000), Frances and Jeanne (2004), Dennis and Katrina (2005) and Alberto (2006). As a result of the 2004 hurricanes, county officials closed the Big Dock because of deteriorating pilings. It would take over a year of discussions and planning before workers would begin to build a new dock, planned for after 2006, rising at least five feet higher than the old dock, extending out 245 feet and having eight finger piers.

CEDAR KEY VILLAGE

In mid-2006, two developers from Siesta Key, Florida, Julie and Roy Norton, announced plans to build a forty-two-room hotel, spa, restaurant, tavern, café, movie theater, two rooftop pools and a parking garage under the buildings on Second Street. They would sell one-eighth shares of $1-million to $2-million townhouses so that 192 club members will share twenty-four residences. The starting price: $173,000. The Nortons also planned to build a twenty-slip marina and pavilion overlooking a bayou; club members would have free use of a fleet of twenty-four boats. The Nortons would encourage guests to park their cars and go around town on golf carts, which many people do now. The developers planned to restore some of the old historic buildings in the area to how they looked between 1870 and 1915.

Conclusion

Today the small town of Cedar Key is surrounded by more than eighty-one thousand acres of wildlife refuge that isolate it from the hectic life of twenty-first century Florida. If it is true that our state sees thousands of new residents moving here each year, the majority of them avoid Cedar Key and head for the busy lifestyle of South Florida. And much of the surroundings of Cedar Key will remain uninhabited by people since wetlands, forests and islands from the Suwannee River and out into the Gulf of Mexico are set aside for the conservation and protection of our nation's fish, bird and wildlife habitats. Cedar Key Scrub State Reserve, Cedar Keys National Wildlife Refuge, Shell Mound County Park and Waccasassa Bay will continue to be pristine places where generations of Floridians will be able to enjoy the outdoor life.

The history of Cedar Key and its nearby islands has been one of might-have-beens and brushes with destiny. The *ifs* of history include these: What if the 1896 hurricane had spared the area? What if Henry Plant had made Cedar Key—and not Tampa—the terminus of his railroad? What if developers had bought up the pristine land before conservationists could buy it for the future? Cedar Key is defined by *resiliency, adaptation to changing times* and *survival*. One can only wonder what the next hundred years will bring.

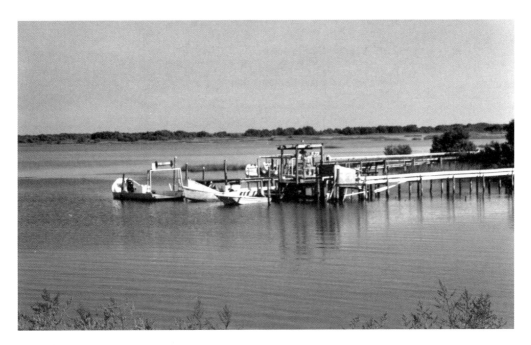

Cedar Key has a working side. *Image courtesy of Kevin M. McCarthy.*

Cedar Key also has a peaceful side. *Image courtesy of Kevin M. McCarthy.*

Further Reading

Andrews, Norene and Katie Andrews, "Atsena Otie Family," *Search For Yesterday: A History of Levy County, Florida*. Bronson: Levy County Archives Committee, September 1990, p. 15.

Burtchaell, Peter Edward. *Economic Change and Population at Cedar Key*. Master's thesis, University of Florida, 1949.

Cohens, Carolyn. *Levy County, Florida*. Black America Series. Charleston, South Carolina: Arcadia Publishing, 2005.

Collins, Toni C. "The 'Big Dock'—A Part of Cedar Key's History," *Cedar Key News*, (vol. 1:13), November 4, 2004, pp. 8–9; December 2, 2004 (vol. 1:15), pp. 1, 11.

———. "Cantonment Morgan on Seahorse Key," *Search For Yesterday: A History of Levy County, Florida*. Bronson: Levy County Archives Committee, 2000, pp. 3–12.

———. "Celebrating Levy Women," *Cedar Key Beacon*, March 22, 2007, p. 6.

Colson, Suzanne, and Leslie N. Sturmer. "One Shining Moment Known as Clamelot: The Cedar Key Story," *Journal of Shellfish Research*, 2000, vol. 19:1, pp. 477–480.

Covington, James W. "The Armed Occupation Act of 1842," *Florida Historical Quarterly*, vol. 40 (July 1961), pp. 41–52.

Day, P.H. *Destination Cedar Key*. As told to and written by Jennie Stevens. 2002.

Dees, Jesse Walter Jr. and Vivian Flannery Dees. *"Off the Beaten Path": The History of Cedar Key, Florida, 1843–1990*. Chiefland, Florida: Rife Publishing, 1990.

Delaino, Doris, Lucille Rogers, and Reverand Barry Andrews. *The History of Cedar Key United Methodist Church, Cedar Key, Florida, 1855–2005*. Cedar Key: Cedar Key United Methodist Church, 2005.

Derr, Mark. *Some Kind of Paradise: A Chronicle of Man and the Land in Florida*. Gainesville: University Press of Florida, 1998.

Dye, R. Thomas. *Race, Ethnicity and the Politics of Economic Development: A Case Study of Cedar Key, Florida*. Florida State University master's thesis, 1992.

Earl, John. *John Muir's Longest Walk*. Garden City, New York: Doubleday, 1975.

Fishburne, Charles C. Jr. *The Cedar Keys in the 19th Century*. Quincy, Florida: Sea Hawk Publications, 1993.

———— *Sidney Lanier: Poet of the Marshes Visits Cedar Keys, 1875*. Cedar Key: Sea Hawk Publications, 1986.

Foster, Barbara. "Dr. J.W. Turner practiced in Cedar Key," *Gainesville Sun*, October 21, 1984.

Hale, Ida L. *Christ Episcopal Church, Cedar Key, Florida, 1868–1968*. Cedar Key: no publisher, 1968.

Hawes, Leland. "1838 Diary Offers Look at 2 Figures" [about Augustus Steele], *Tampa Tribune, Bay Life* section, Aug.1, 1993, p. 4.

———— "County Began Due to Steele's Mettle" [about Augustus Steele], *Tampa Tribune, Bay Life* section, January 24, 1984, p. 1.

Holland, Jack. "Early Newspapers," *Search For Yesterday: A History of Levy County, Florida*. Bronson: Levy County Archives Committee, June 1985, chapter 14, pp. 1–29.

Keith, Carol. *A Watch for Evil*. Philadelphia: Xlibris, 2004.

Knauss, James Owen. *Territorial Florida Journalism*. DeLand, Florida: Florida State Historical Society, 1926.

Klinkenberg, Jeff. *Real Florida*. Asheboro, North Carolina: Down Home Press, 1993, pp. 122–125 [about Harriet Smith].

Lanier, Sidney. *Florida: Its Scenery, Climate, and History*. Gainesville: University of Florida Press, 1973 (a facsimile of Lanier's 1875 edition.)

Lindsey, Lindon J. *Cemeteries of Levy and Other Counties*. 1994.

Mahon, John K. *History of the Second Seminole War*. Gainesville: University of Florida Press, 1967.

Matheson, Sarah. "Judge Augustus Steele and Atsena Otie," talk given to the Cedar Key Historical Society, November 13, 1980.

McCarthy, Kevin M. *Black Florida*. New York: Hippocrene Books, 1995, especially pp. 254–255: "Rosewood."

———. *Florida Lighthouses*. Gainesville: University Press of Florida, 1990, especially pp. 101–104, "Seahorse Key Lighthouse."

———. *Thirty Florida Shipwrecks*. Sarasota: Pineapple Press, 1992, especially pp. 96–99: "*City of Hawkinsville, 1922*."

Muir, John. *A Thousand-Mile Walk to the Gulf*, edited by William Frederic Badè. Boston: Houghton Mifflin Company, 1916.

Robbins, G.T. "Some Highlights From Ten Years as the High Sheriff of Levy County," *Search For Yesterday, A History of Levy County, Florida*. Bronson: Levy County Archives Committee, chapter 9 (April 1980), pp. 4–21.

Roberts, Anna Rae. "The Ghost Lady of Shell Mound," *Cedar Key Beacon*, April 23, 1992, p. 10.

———. "The Ghost Lady of Shell Mound: She Appeared Again," *Cedar Key Beacon*, October 15, 1992, p. 20.

Shofner, Jerrell H. *Nor Is It Over Yet: Florida in the Era of Reconstruction, 1863–1877*. Gainesville: University Presses of Florida, 1974.

Smith, Harriet. *A Naturalist's Guide to Cedar Key, Florida: Including 19 Self-guided Walks and Boat Trips in Cedar Key and Surrounding Area, With Information about Birds and Plants of the Area*. Cedar Key: H. Smith, 1987.

Stacy, Mitch. "Ghost of Shell Mound," *Gainesville Sun*, October 30, 1993, p. 5D.

Thompson, Roger M. "The Decline of Cedar Key: Mormon Lore in North Florida and Its Social Function," *Southern Folklore Quarterly*, 39 (1975), pp. 39–62.

Trunk, Denise. "Key Changes," *National Fisherman*, vol. 84: 3 (July 2003), pp. 20–21.

Verrill, Ruth. *Romantic and Historic Levy County*. Gainesville, Florida: Rose Allen, 1976.

Wells, William R. II, "Crisis at Cedar Keys" (about Mayor William Cottrell), *United States Navel Institute Naval History*, April 2002, pp. 41–45.

Whitman, St. Clair. *Recollections of St. Clair Whitman*. Cedar Key: Cedar Key Museum State Park, no date.

Wolfe, Linnie Marsh. *Son of the Wilderness: The Life of John Muir*. New York: Knopf, 1945.

Yearty, William A. *Search For Yesterday: A History of Levy County, Florida*. Bronson: Levy County Archives Committee, January 1982, Chapter Eleven, pp. 2–11.

About Kevin M. McCarthy

Kevin M. McCarthy (1940–) was born and raised in New Jersey. After graduating from LaSalle College (1963), he spent two years in the U.S. Peace Corps, teaching English in Turkey. He then earned a master's degree in American literature (1966) and a Ph.D. in linguistics (1970). He taught at the University of Florida for thirty-seven years (1969–2005), as well as one year in Lebanon and two years in Saudi Arabia as a Fulbright Professor. He has had thirty-six books published, most of them about Florida. He is married to Karelisa Hartigan and has four children.